IMAGES
of America

SOUTH CAROLINA
LIGHTHOUSES

IMAGES
of America

SOUTH CAROLINA LIGHTHOUSES

Margie Willis Clary and Kim McDermott

ARCADIA
PUBLISHING

Published by Arcadia Publishing
Charleston, South Carolina

Printed in the United States of America

Library of Congress Catalog Card Number: 2007943610

For all general information contact Arcadia Publishing at:
Telephone 843-853-2070
Fax 843-853-0044
E-mail sales@arcadiapublishing.com
For customer service and orders:
Toll-Free 1-888-313-2665

Visit us on the Internet at www.arcadiapublishing.com

CONTENTS

ACKNOWLEDGMENTS

Numerous individuals, museums, libraries, and families of lighthouse keepers provided support and assistance in the gathering of necessary materials to complete this project. A special appreciation to Theresa Roberts and her staff at the Charleston Coast Guard Base for making available the archival pictures from the former Lighthouse Sixth District (discontinued in 1939). A particular thanks to the staffs of the Charleston County Library, the Charleston Library Society, the South Carolina Room at the College of Charleston's Addlestone Library, the Beaufort County Library, the Hilton Head Library, and the Village Museum in McClellanville, South Carolina, for their helpfulness in locating pictures for use in this project.

Thanks to Geraldine Spencer Hall for sharing her family's picture album of her life on North Island during World War II. To the other members of lighthouse families who graciously appreciated the fact that the project would enhance their memories of the lighthouse service, we recognize the following: Fred Wichmann and Robert Simms of Charleston; Laura Wichmann Hipp, Ethel Svendsen, and Arthurene Ellis Hunt of James Island; Billie Burn of Savannah, Georgia; and Don Edney of Dallas, Texas.

To the photographers who shared their skills, we say thank you: Michael Willis of Laurens; Richard Beck of Folly Beach; Larry Peterka and Preston Hipp of Charleston; Dr. Stephen Wise and Bryan Howard with the Parris Island Museum; Capt. Joe Yocius of Daufuskie Island; Robert Chapell, Marilyn Muckenfuss, and Shelby Green of James Island; Wayne Clary of Charleston; Ernest Ferguson of Winnsboro, South Carolina; and Kraig Anderson of www.lighthousefriends.com.

A particular thanks to the Save the Light Foundation of Charleston, whose members so obligingly provided extensive information and pictures into the past and future of the Morris Island Light, especially the Craig/Davis album.

Thanks to the St. Augustine Lighthouse and Museum and the Florida Lighthouse Association for locating images of lighthouse keepers that once served in South Carolina lighthouses. Thanks to the Ponce de Leon Inlet Lighthouse Preservation Association for their willingness to help.

Thanks to the U.S. Coast Guard, the National Archives, the Library of Congress, and author John Hairr for the use of archival photographs.

INTRODUCTION

In 1663, King Charles II granted the territory called Carolina to eight of his supporters. These men called themselves the Lord Proprietors. The success of the Carolina Colony rested directly in their hands. In April 1670, a 200-ton vessel called *Carolina* brought colonists to the New World. It entered a river called the Kiawah (later renamed the Ashley). Her passengers disembarked on Albemarle Point to begin the first settlement in the Carolinas, called Charles Towne. The colonists built a town and a government. The location of Charles Towne did not suit everyone, and many settlers died from the diseases they encountered, which were caused by unsanitary conditions in the settlement. Along with disease, the settlers feared wild animals, Native Americans, and the possibility of starvation.

By 1671, the town began to move to Oyster Point on the peninsula between the Ashley and Cooper Rivers to its present location. By 1680, the entire town had moved. The town was called Charleston, and Albemarle Point was referred to as Old Town.

Having relocated between two rivers, international trade increased greatly. Ships bringing imports came regularly into Charleston Harbor. The town soon realized there was a need for signals to warn ships of treacherous shorelines and to guide them safely to port. The first signals were fires built atop sand dunes and cliffs near the dangerous shores. Later towers were erected to provide an unobstructed view as ships entered the port.

In 1673, three years after the colony of Charles Towne was settled, the colony authorized a light to be burned every night near the entrance to Charleston Harbor. This unadorned beacon was described as a burning "fier" fueled by pitch and oakum in an open basket of iron. The iron basket was used into the 18th century. About 1716, huge tallow candles encased in a lantern were added to give more light. The candles were not effective at a distance. Spider lamps, which used whale oil, replaced the candles.

In 1750, England's King George III passed an act calling for the construction of a permanent beacon at the entrance of Charleston Harbor. It was to be completed by 1765. However, funds were diverted in late 1757 for the construction of the steeple on Saint Michael's Church in the city. Ten years later, the king again called for the construction of a permanent lighthouse for the harbor. On May 30, 1767, the cornerstone was laid for the first Charleston Lighthouse, later to be called the Morris Island Light. The octagonal-shaped lighthouse was designed by Samuel Cardy (also spelled Cordy) and was built by Adam Miller. It stood 43 feet above low tide. Lamps suspended in the dome burned whale oil. Over the door of the lighthouse, a copper plate was placed. It was inscribed with the following: "The first stone of this beacon was laid on the 30th of May 1767 in the seventh year of his Majesty's Reign, George the III."

The copper plate was later stolen by vandals while in private possession.

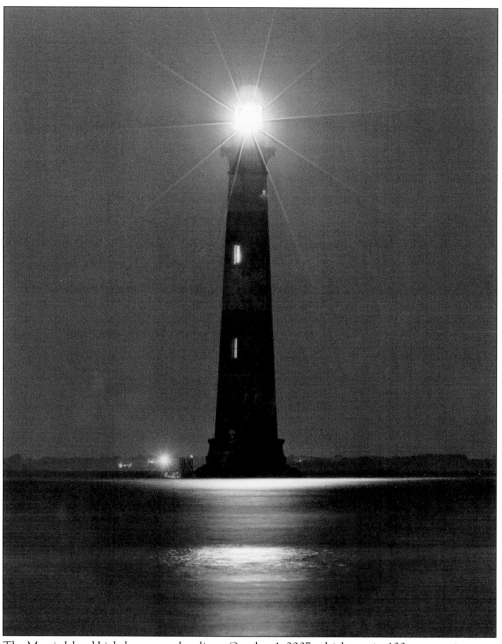

The Morris Island Lighthouse was last lit on October 1, 2007, which was its 130-year anniversary. (Courtesy of Larry Peterka.)

One

MORRIS ISLAND LIGHT

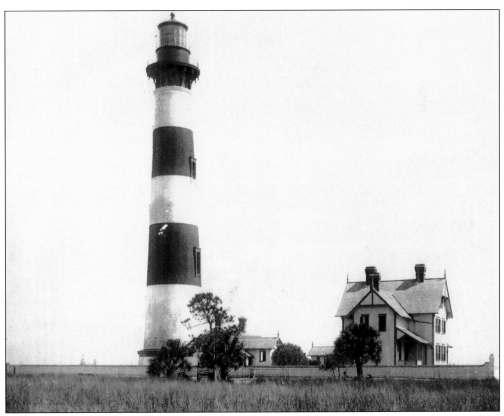

The first lighthouse to be constructed at the mouth of Charleston Harbor was authorized by King George III. It was completed in 1767 and was called the Charleston Lighthouse. It would later be known as the Morris Island Light. It was the first lighthouse station built in the colonies. The tower was darkened during the American Revolution and remained that way until 1785. On August 7, 1789, U.S. Congress established the U.S. Lighthouse Establishment, and all Southern lighthouses were transferred to the management of the federal government. In 1802, the Morris Island lighthouse's tower was raised from 42 feet above sea level to 102 feet. In 1812, the lighthouse was equipped with an Argand lamp. The lamp used whale oil and incorporated a reflector system to increase its brightness. (Courtesy of U.S. Coast Guard.)

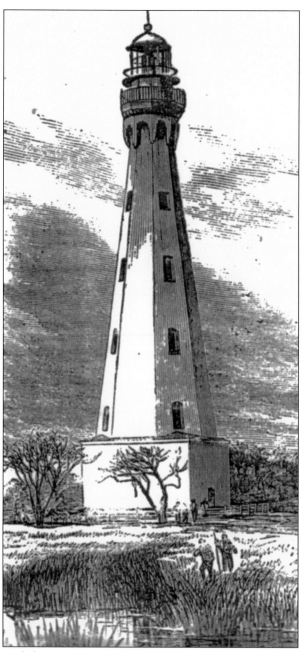

This drawing is the only known picture of the 1838 Morris Island Light. The drawing appeared in the *Leslie Illustrated Weekly Magazine* prior to the Civil War. The tower was constructed in 1838 to replace the 1767 tower. The tower stood 102 feet tall. Its revolving light was made up of 12 lamps with 21 reflectors. In 1854, a hurricane hit the Carolina coast, and the two keeper's dwellings were destroyed. The tower suffered minor damage but remained standing. Repairs were completed in 1858. The lighthouse was described on a nautical chart of the Charleston Harbor in 1858 as follows: "The lighthouse is on the North end of Morris Island and is fixed light. The lantern is 133 feet above the level of the sea and in clear weather can be seen seventeen miles." (Courtesy of Save the Light Foundation.)

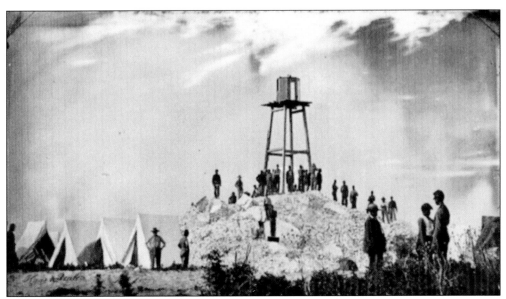

The 1858 Morris Island Light was used for only three years. In 1861, as the Civil War began, all Southern lighthouses were darkened or destroyed. In 1861, the Morris Island Light was dismantled. The second-order lens was removed from the tower and is believed to have been either buried on the island or stored. The tower was converted into an observation tower manned by cadets from The Citadel, a military school in Charleston. The picture above reveals the structure of the observation platform erected on the ruins of the lighthouse. Note the military encampment around the tower. It is not known if it is a Union or Confederate camp because both armies occupied the area at one time during the war. (Courtesy of Library of Congress.)

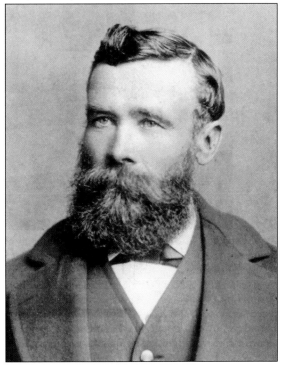

In 1873, Maj. Peter Hains of the U.S. Army Corps of Engineers designed the new Morris Island tower. His plan called for 264 pilings to be driven 50 feet into the sand at 2.8 inches apart. The cofferdam needed for the construction would be left in place to add strength. In addition to Major Hains being a well-respected creator of lighthouses, he was also celebrated as the soldier who fired the first shot for the Union Army in an early battle at Manassas. (Courtesy of Save the Light Foundation.)

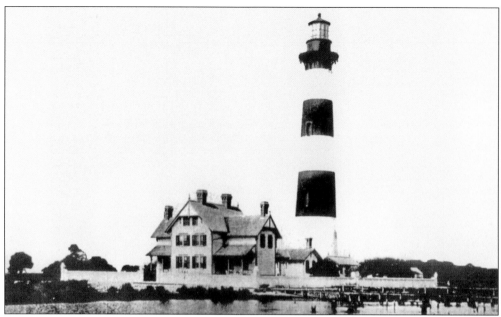

The keeper's quarters were replaced in 1876. New oil and wick sheds were added. The keeper's family, two assistants, and their families lived in the one three-story, wooden, triplex house. Within a few years, there were 15 buildings on the compound, including three dwellings, an outbuilding, chicken houses, barns, and a schoolhouse for the children. The compound was surrounded by a concrete wall to separate family life from the rest of the island. (Courtesy of U.S. Coast Guard.)

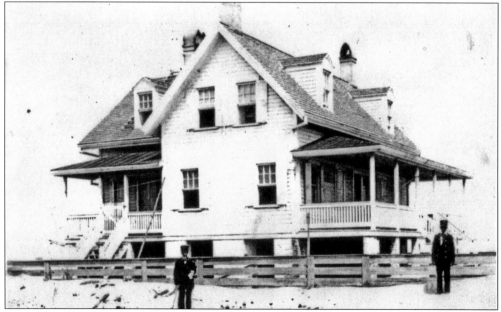

Records say that this c. 1885 photograph is of the assistant keeper's dwelling with two unidentified attendants. The site on which the dwelling was built provided beacons to guide ships in and out of Charleston Harbor for decades. As early as 1789, the newly formed United States accepted jurisdiction over the eight already existing lighthouses. The Charleston Light was the only one in the South. (Courtesy of U.S. Coast Guard.)

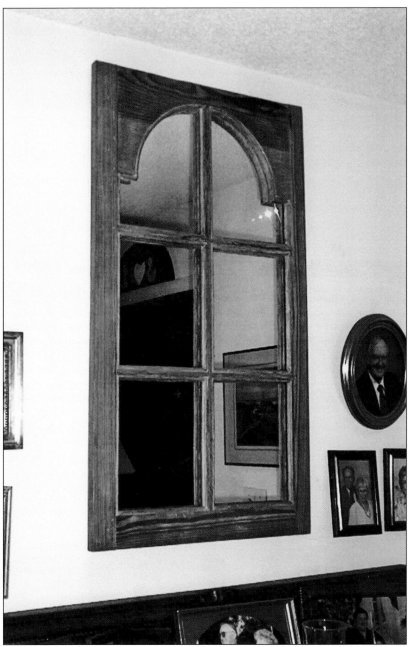

This is one of the original window frames from the keeper's dwelling of 1876. When the Morris Island Light was automated in 1938, Dr. Richard Prentiss of Charleston purchased the house for the sum of $55. The house was dismantled and was floated on a barge to Edisto Island. In dismantling the house, they found that it had been constructed with pegs. No nails had been used. Two beach houses were erected from the materials of the house. The houses stood until a storm washed them away in the early 1900s. Prentiss's adopted son Milton M. Muckenfuss Sr. of Yonges Island salvaged the window frame. It is now owned by Muckenfuss's son Milton Jr. and his wife, Marilyn. The glass has been replaced with mirrors. It is proudly displayed in their home on James Island. (Courtesy of Milton and Marilyn Muckenfuss.)

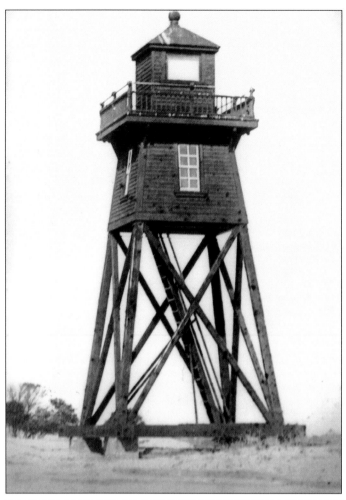

In 1867, funds were appropriated for the building of range lights on Morris Island. Two short-range beacons were built. A third beacon had a 35-foot-tall skeletal frame tower. At its top were a lantern and a small, 7-foot-tall observation room. These range lights were used during the years that the Morris Island Station was out of commission because of damage sustained during the Civil War. The lights led mariners through the shifting channel when entering Charleston Harbor. (Both courtesy of U.S. Coast Guard.)

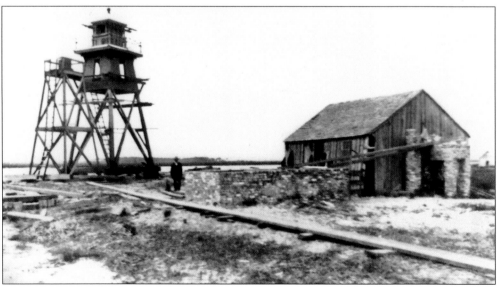

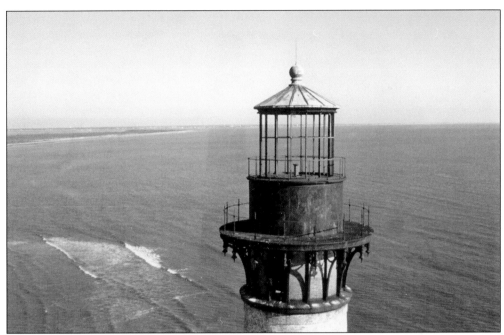

The lantern room from the 1876 lighthouse has remained intact throughout the years. It withstood the hurricane of 1885 and the Charleston earthquake of 1886. In 1989, it stood firm through the heavy winds of Hugo, a category five hurricane. Although the tower still stands firm, the surrounding shoreline continues to erode at the average rate of two miles per year. This heavy erosion is thought to have been caused by the jetties built after the Civil War. They were designed to make the harbor channel deeper. In 1880, the Morris Island Light was 2,700 feet from the shoreline. By 1938, the lighthouse was on the shoreline. Today it stands more than 200 feet off shore, and the erosion continues. (Both courtesy of Richard Beck.)

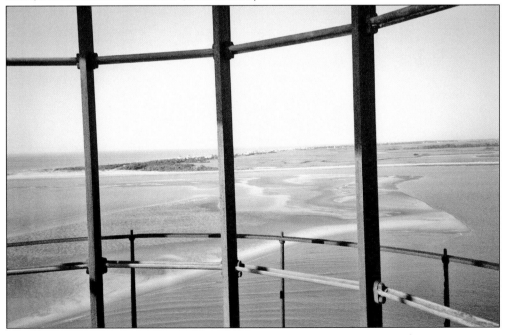

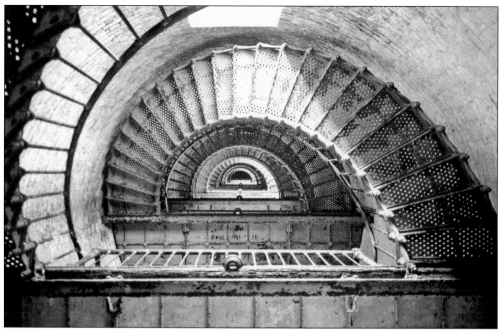

The staircase of the Morris Island Light is made of iron and has nine flights spiraling up to the lantern room. On the east and west walls segmented, arched windows alternate levels to supply natural light. (Courtesy of Richard Beck.)

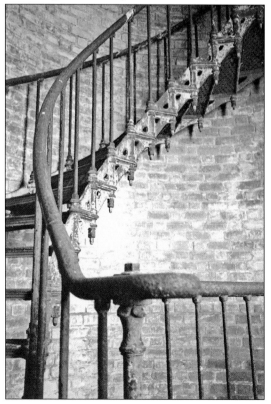

The iron steps are now in great disrepair. Several are missing. Rust hangs from the once beautifully designed winding staircase. The Save the Light Foundation has plans to repair the stairs in the future. (Courtesy of Richard Beck.)

In 1885, a severe hurricane struck Charleston, which caused damage to the Morris Island compound. The brick wall was partially destroyed, and the wooden walkway connecting the lighthouse to the keeper's house was washed away. The greatest damage was the loss of the 35-foot range light. A year later, the earthquake of 1886 took its toll on the lighthouse, throwing the lens out of position and cracking the tower in two places. However, the quake did not jeopardize the lighthouse's stability. The lens was repaired immediately, and the broken parts of the tower were mended without delay. (Courtesy of U.S. Coast Guard.)

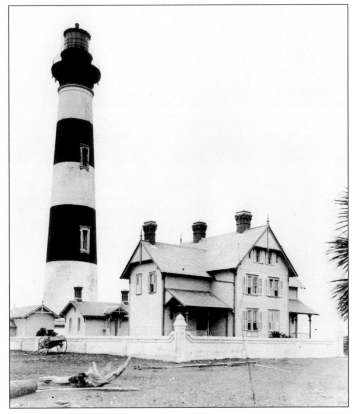

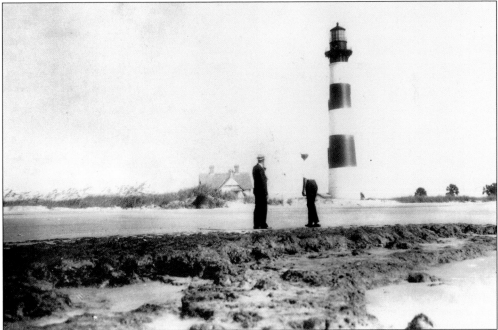

Two unidentified gentlemen survey the damage from the earthquake of 1886. (Courtesy of Save the Light Foundation.)

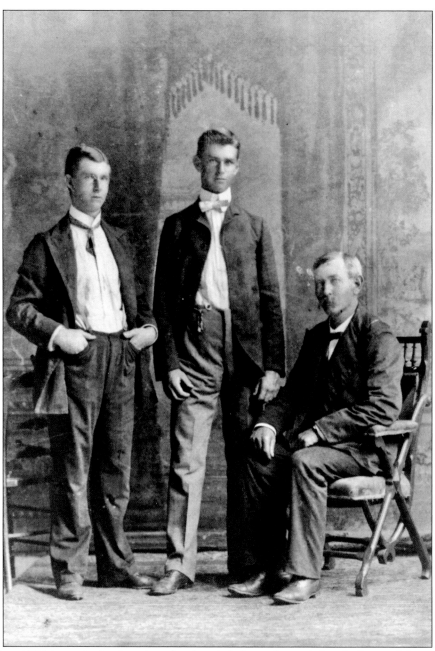

In this *c*. 1900 image is the Svendsen family, a lighthouse keeper's family. Pictured from left to right are Carl Olaf Svendsen (son), Halvor Samuel Svendsen (son), and Halvor Harold Svendsen Sr. (father). Halvor Sr. was the lighthouse keeper for the Morris Island Light from 1891 to 1896. Carl was at Morris Island in the early 1900s. Halvor Jr. was the lighthouse keeper for Sullivan's Island from 1906 to 1918. Halvor Sr. was transferred to the Bull's Bay Lighthouse in 1896. He was the keeper there until his sudden death in 1905. He spent 23 years in the U.S. Lighthouse Establishment. He served at Hunting Island, Cape Romain, Hilton Head Island, Morris Island, and at Bull's Bay. His son Carl was transferred to the St. Simons Lighthouse in Georgia, where he retired after 28 years of service. (Courtesy of Ethel Svendsen and Betty Svendsen Snyder.)

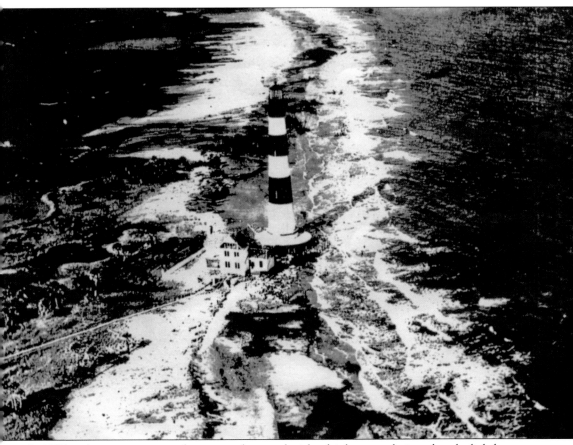

In 1935, as the ocean continued to encroach upon the island, it became obvious that the lighthouse must be automated, and the keepers relocated to the Lighthouse Depot in Charleston. On June 22, 1938, the first-order lens was removed and a more modern optic one was installed. The replacement light was a four-power acetylene lens with 6,000 candle power. A bulkhead was constructed around the tower in an effort to ward off erosion. (Courtesy of U.S. Coast Guard.)

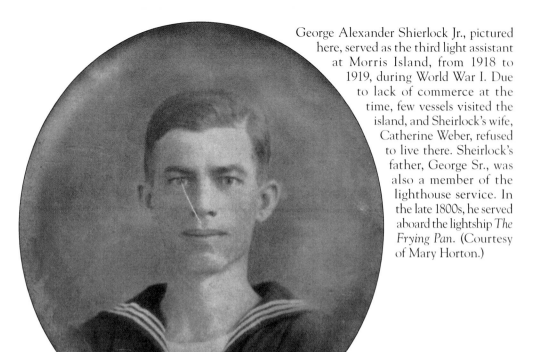

George Alexander Shierlock Jr., pictured here, served as the third light assistant at Morris Island, from 1918 to 1919, during World War I. Due to lack of commerce at the time, few vessels visited the island, and Sheirlock's wife, Catherine Weber, refused to live there. Sheirlock's father, George Sr., was also a member of the lighthouse service. In the late 1800s, he served aboard the lightship *The Frying Pan*. (Courtesy of Mary Horton.)

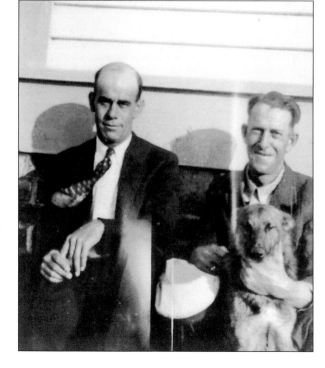

W. A. Davis (left) was a lighthouse keeper from 1920 to 1935. He is shown here with his assistant William Hecker, who was the keeper from 1925 to 1938. Davis and Hecker were two of the last keepers whose families also lived on Morris Island. (Courtesy of Save the Light Foundation.)

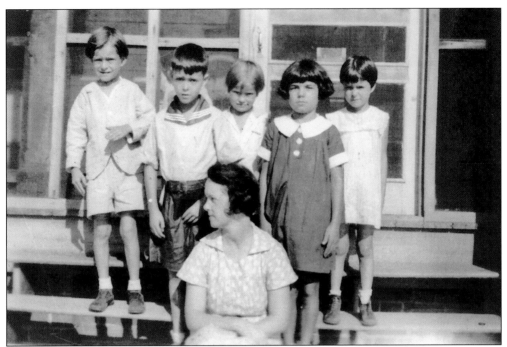

The education of the keeper's children was important to the families that resided at the Morris Island Station. The need of a teacher depended on how many children lived at the station. If only two children needed schooling, they were sent to school on James Island during the week and returned to Morris Island on Fridays. In the late 1920s and into the 1930s, the county hired a full-time teacher for the keeper's children. The teacher boarded in the keeper's dwelling. Pictured *c.* 1935, teacher Elma Bradham of John's Island is shown with her classroom of children, which included the Davis and Hecker children. (Courtesy of Save the Light Foundation.)

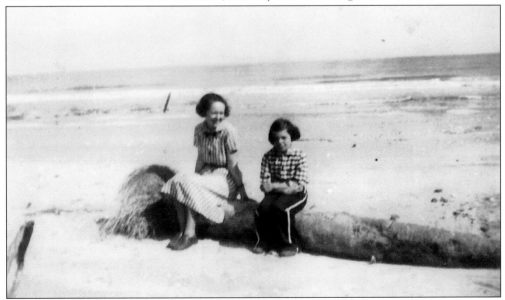

Teacher Elma Bradham is pictured with Sara Davis, sitting on an uprooted palm tree (Courtesy of Save the Light Foundation.)

Pictured here is Mrs. W. A. Davis, holding her newborn baby. The baby was known as the "Storm Baby" because he was born on Morris Island during a storm that kept Mrs. Davis from getting to a hospital for the delivery. The Davis's middle child, Katherine, is also pictured. (Courtesy of Save the Light Foundation.)

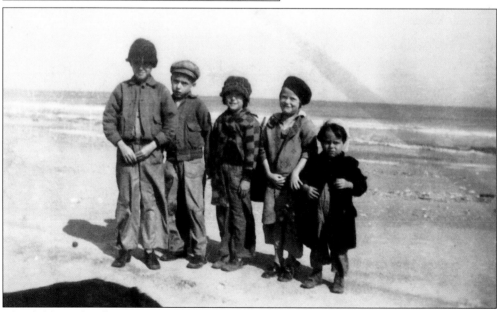

The children of William Hecker were William, Alice, Ester, Charles, Jim, and June. Five of them are pictured here in no particular order c. 1930. During the 1930s, there were 10 children living in the keeper's house. The dwelling housed three lighthouse keepers and their families. The Hecker children believed that the lighthouse was haunted. On one occasion, a man jumped to his death from the tower. Another man was found in one of the closets in a building on the island with his throat cut. The murder was never solved. (Courtesy of Save the Light Foundation.)

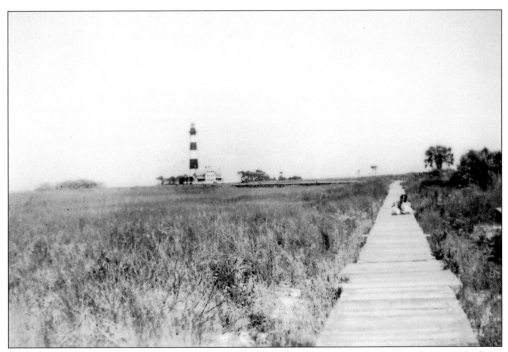

A wooden walkway led from the keeper's house to the pier. The pier was less than a mile from Folly Beach. The lighthouse keeper's car was parked on Folly Beach when not in use. (Courtesy of Save the Light Foundation.)

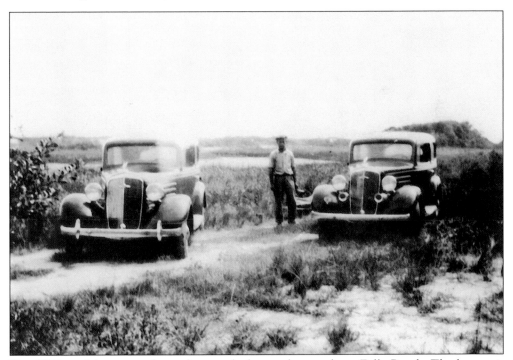

Two 1930-model cars are shown here parked near the marsh on Folly Beach. The keeper is unidentified. (Courtesy of Save the Light Foundation.)

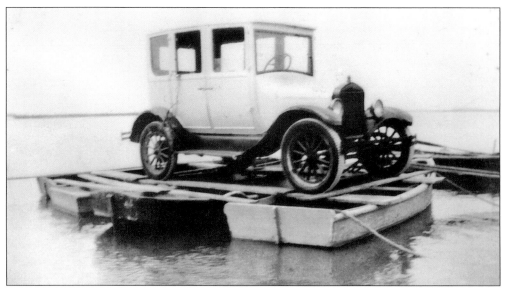

Edward Meyers, the lighthouse keeper from 1933 to 1935, hired two boats and employed two men to tie his Ford Model T onto the small vessels in order to float his car to Morris Island. Meyer did not have to have a driver's license because there were no state roads on the island. When the car quit running after a year, it became a chicken coop. (Courtesy of Save the Light Foundation.)

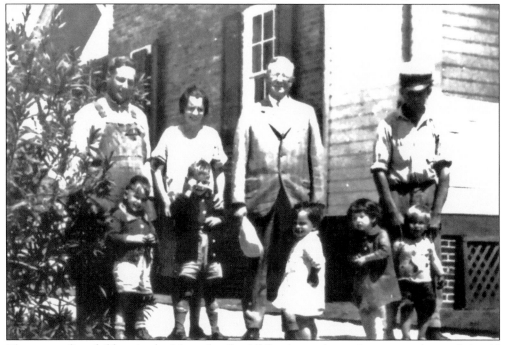

There were five children in the Meyer family. All five learned to swim at an early age. It is said that Meyer (far left) would take his family down the walkway connecting the house to the boat provided by the Lighthouse Service to cross over the river to Folly Beach. The family would get into the Ford Model T, before it was brought to the island, and go into the city to collect their mail and needed supplies. Also pictured c. 1933 with the Meyers family are two unidentified gentlemen. (Courtesy of Ponce De Leon Lighthouse and Museum.)

In 1935, a terrible storm surge swept over Morris Island. The water rushed over the high concrete walls enclosing the compound and washed away the chickens, pigs, turkeys, and other small animals. It washed the Meyers' Ford Model T out to sea. With this destruction, lighthouse keepers left the island, and the station was never inhabited again. Pictured here is Mrs. Davis and her daughter Sara. (Courtesy of Save the Light Foundation.)

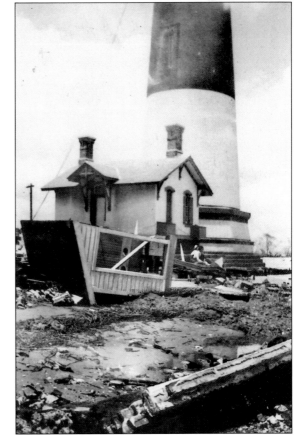

The compound was almost destroyed by the 1935 storm surge; however, the Morris Island tower stood firm. (Courtesy of Save the Light Foundation.)

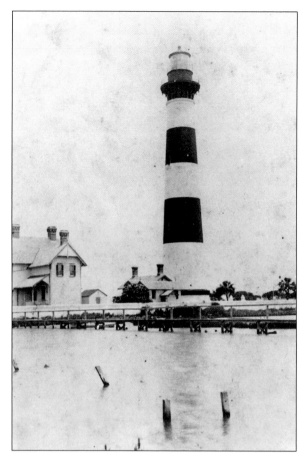

In 1935, erosion had all but destroyed the land around the keeper's dwelling, as shown in this photograph. It was obvious that the lighthouse would have to be automated and the compound vacated. On June 22, 1938, the first-order lens was removed, and a modern optic one was installed. The contractor built a bulkhead around the tower to try to contain the erosion. Finally, it was decided to raze the buildings left on the island. It was feared that if they were left to wash away, the debris could become hazardous to navigation. (Courtesy of U.S. Coast Guard.)

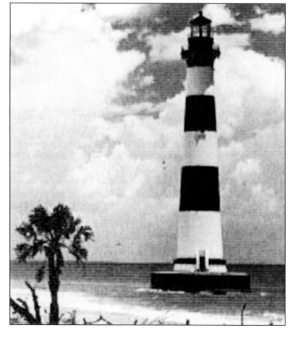

Ten years after the light was automated, the ocean continued to play havoc with the land around the lighthouse, seen here about 1948. The lighthouse needed only monthly inspection to check on the automated lens. (Courtesy of U.S. Coast Guard.)

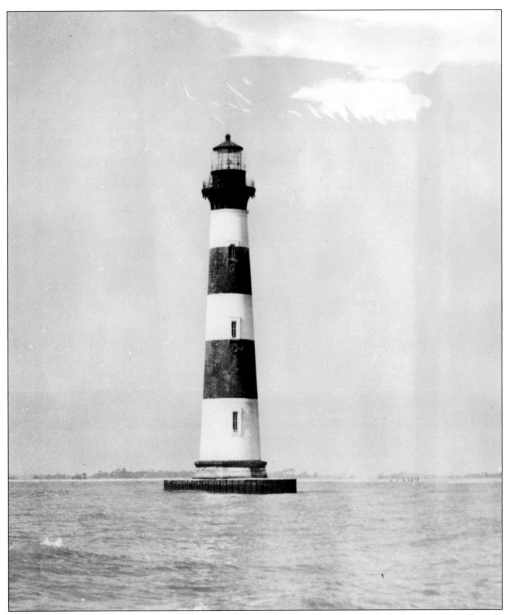

In 1956, the U.S. Coast Guard announced plans for building a new lighthouse on Sullivan's Island. The plan was to auction off the Fresnel lens from the Morris Island Lighthouse (seen here about 1955), which was in storage. However, it was decided that the lens would be given to the S.C. Department of Parks and Recreation. The lens was put in a museum at the Hunting Island Lighthouse, and it resides there today on the first floor. (Courtesy of U.S. Coast Guard.)

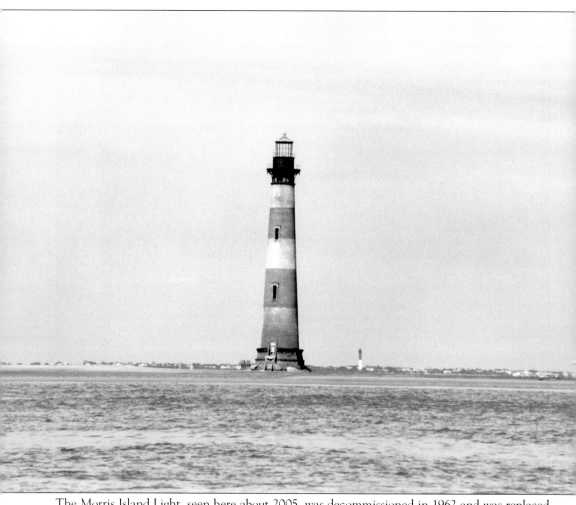

The Morris Island Light, seen here about 2005, was decommissioned in 1962 and was replaced by the new Sullivan's Island Light. Both lighthouses can be seen in the photograph. (Courtesy of Preston Hipp.)

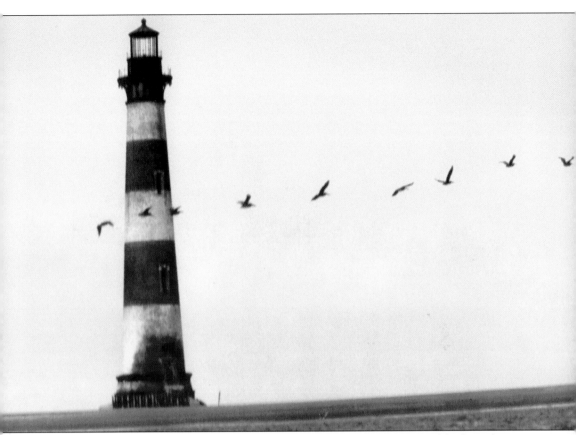

In this photograph, one can see several brown pelicans, once an endangered bird on the sea islands around Charleston. These birds have since made a comeback to area beaches. (Courtesy of Preston Hipp.)

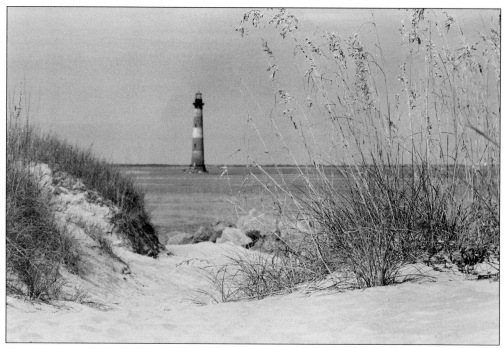

From the east end of Folly Beach, the lighthouse looks very close to land. But the island is no more than a sandbar at low tide. No one should even think of walking or swimming to the lighthouse because of treacherous waters and deadly undercurrents.

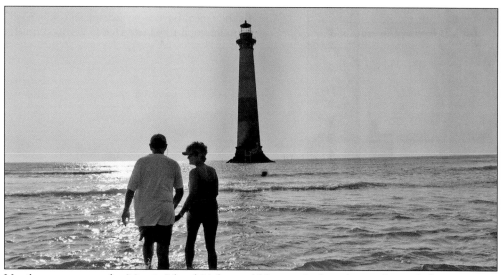

Until recent years, the Morris Island Light could be reached on foot at low tide by crossing a sandbar from Folly Beach. Due to the continuing heavy erosion, the tower now stands hundreds of feet offshore. The tower can be seen from the east end of Folly Beach but is best observed from the harbor by boat. (Courtesy of Richard Beck.)

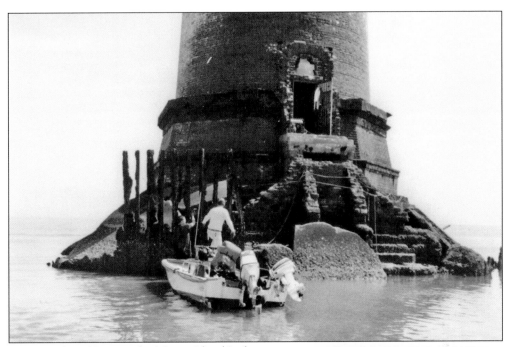

For more than 30 years, the Morris Island Light stood vacant and neglected. It was also vandalized. In 2000, the lighthouse was posted with warnings to prevent additional vandalism. In the photograph above, members of the Save the Light Foundation are arriving at the lighthouse for a weekly inspection. The picture below shows the posted signs on the door of the lighthouse. A new iron gate has been added for further protection from vandals. (Both courtesy of Save the Light Foundation.)

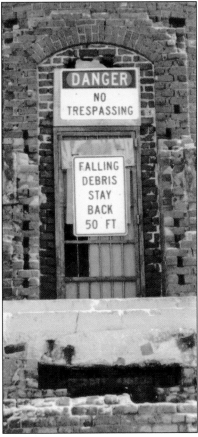

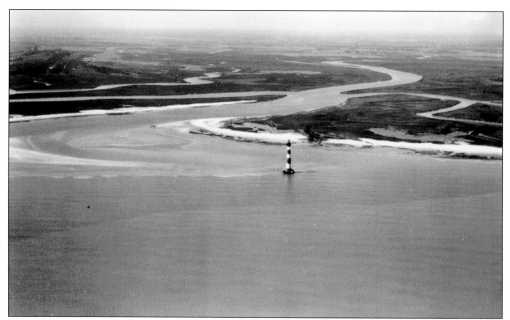

This photograph was taken from the air by the U.S. Coast Guard. From this view, it is difficult to believe that the Morris Island Light once stood in the middle of an island with 15 buildings surrounding it. It now stands more than 2,000 feet from the shoreline of Morris Island. (Courtesy of U.S. Coast Guard.)

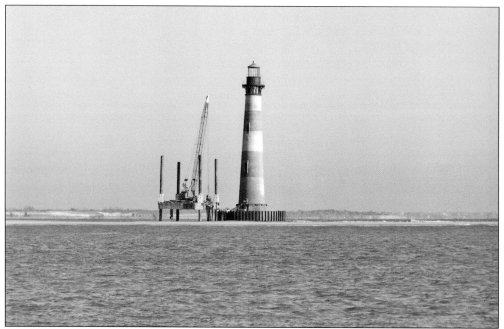

By 2007, the Save the Light Foundation had raised the money needed to stabilize the foundation of the Morris Island Light. In August 2007, the Taylor Brothers began to construct a cofferdam ring and started the process of bedding the riprap around the base. The work was completed in February 2008. On January 1, 2008, the State of South Carolina gave a check for an additional $500,000 to be used toward the second phase of reconstruction. (Courtesy of Bob Chapell.)

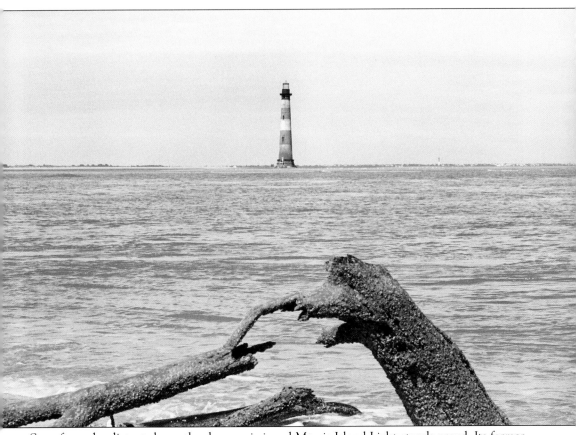

Seen from the distant shore, the decommissioned Morris Island Light stands proud. Its former compound has eroded away. No longer can childhood memories be made on the island. But the lighthouse still faithfully guards Charleston Harbor. With the help of all who love the Morris Island Light, hopefully the lighthouse will stand another 130 years. (Courtesy of Michael Willis.)

The Morris Island Light, which has been extinguished since June 15, 1962, was aflame once more during May 2002, when Kim Sooja lit the tower as a visual arts exhibit during the 26th annual Spoleto Festival U.S.A. Propane gas was used to power a generator that drove the illumination system. Floodlights underneath the walkway and on top of the tower changed the light's color from white to green, to red, to blue, and to purple. (Courtesy of Larry Peterka.)

Two

GEORGETOWN LIGHT

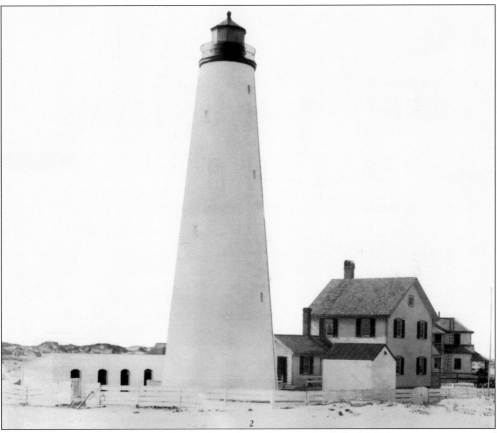

Shortly after the colonies gained their independence from England, the U.S. Congress appropriated $5,000 to build a lighthouse at the entrance to Winyah Bay. In 1795, Paul Trapier donated seven acres of land on North Island for the building of the lighthouse. The lighthouse was completed in 1801. Seventy-two feet tall, the wooden structure, pictured here about 1929, was built on a brick foundation and measured 26 feet at the base, tapering 12 feet at the top. The lantern room was made of cast iron, was 6 feet in diameter, and accommodated a whale oil–burning lamp. The tower was painted white, while the lantern room was painted black. A white fence surrounded the compound. (Courtesy of John Hairr.)

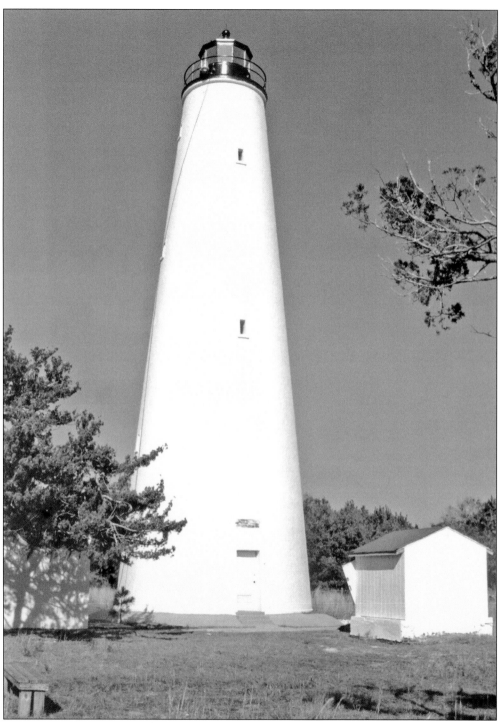

In 1806, a violent storm hit North Island and destroyed the wooden tower. A new tower constructed of brick was completed in 1812. It was conical shaped, and its walls were 3 feet thick at the base. In 1855, the light was upgraded to a fourth-order Fresnel lens. In 1890, an oil house was added to the lighthouse station. A boathouse was built in 1894. (Courtesy of Kraig Anderson.)

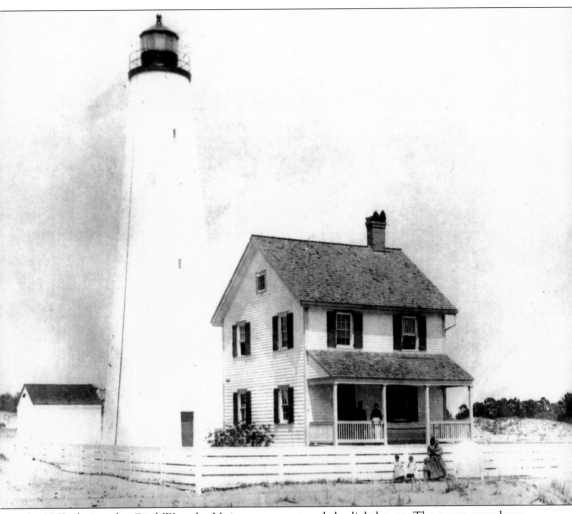

In 1862, during the Civil War, the Union army captured the lighthouse. The tower, seen here about 1885, was heavily damaged. When repaired in 1867, the tower was expanded to 87 feet with a central plane of 85 feet. Keepers walked 124 stone steps to the top. The light was equipped with a fifth-order Fresnel lens. (Courtesy of U.S. Coast Guard.)

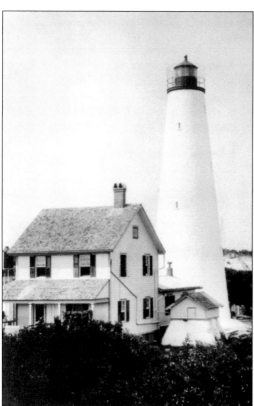

This photograph of the Georgetown Lighthouse was taken about 1942, during World War II. (Courtesy of U.S. Coast Guard.)

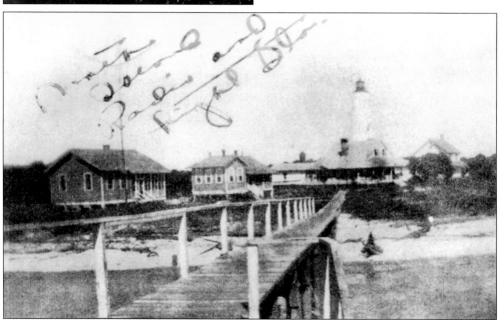

In 1928, Gabriel Nelson Jackson was assigned as the communicator at the North Island radio station. The two houses in the foreground of this picture are navy housing units. Jackson stayed in one of them. The lighthouse can be seen in the distance behind the keeper's house. All of these buildings have been razed. (Courtesy of Donald Edney.)

Gabriel Jackson served with the Lighthouse Service from 1928 to 1937. He was the keeper of the harbor lights in Georgetown and was a communicator at the North Island radio and flight station before being assigned to the Georgetown Light as head keeper in 1933. (Courtesy of Donald Edney.)

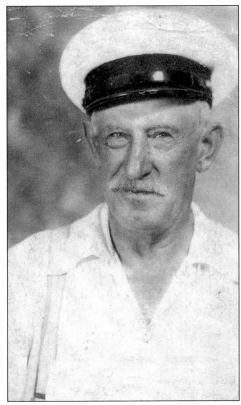

Donald Edney, a grandson of lighthouse keeper Gabriel Jackson, lived on North Island with his grandparents from 1933 to 1936. He is pictured here about 2001 with his wife, Mary Ann. Edney now lives in Dallas, Texas. (Courtesy of Donald Edney.)

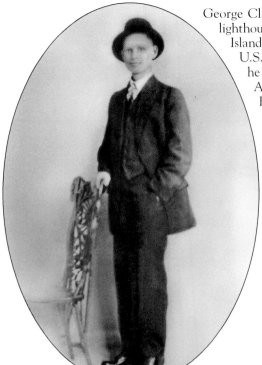

George Clarence Ellis was from Charleston and was lighthouse keeper Gabriel Jackson's assistant at North Island from 1924 to 1937. Ellis had served with the U.S. Wildcat Division in World War I. In 1918, he married Beatrice Louise Burn, a daughter of Ashley Burn, the lighthouse keeper on Daufuskie Island. The Ellises had six children. (Courtesy of Robert Simms.)

Pictured about 1930 is Louise Burn Ellis, wife of assistant lighthouse keeper George Clarence Ellis. Louise was only 13 when she married George, but she told him she was 16. (Courtesy of Arthurene " Susie" Ellis Hunt.)

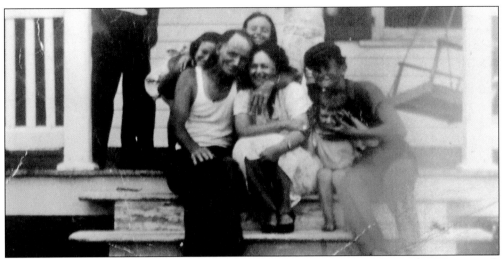

Pictured in this c. 1935 photograph are George Clarence Ellis and his wife, Louise, with several of their six children. The children were Arthur Cunningham Ellis, Claude Leroy Ellis, Joseph Samuel Ellis, Elizabeth Ann Ellis, Beatrice Patat Ellis, and George C. Ellis. This picture may have been the last Ellis family picture taken before George was killed during an explosion that occurred on a boat he was riding from Charleston to North Island. Keeper Gabriel Jackson was also on the boat, but he survived, although he was treated for burns over 90 percent of his body. After the accident, Jackson remained in the hospital for quite some time and returned to the lighthouse only to remove his furniture. (Courtesy of Robert Simms.)

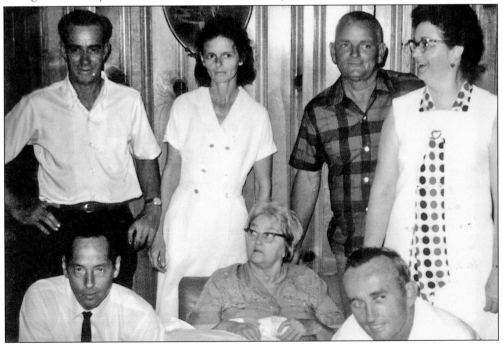

The Ellis children are shown here at a 1970 family reunion. From left to right are the following: (first row) Claude Leroy Ellis, Louise Burn Ellis Hippchem (their grandmother), and Joseph Samuel Ellis; (second row) Arthur Cunningham Ellis, Elizabeth Ann Ellis Taylor, George C. Ellis, and Beatrice Patat Ellis Bond. Hippchem died that same year. (Courtesy of Robert Simms.)

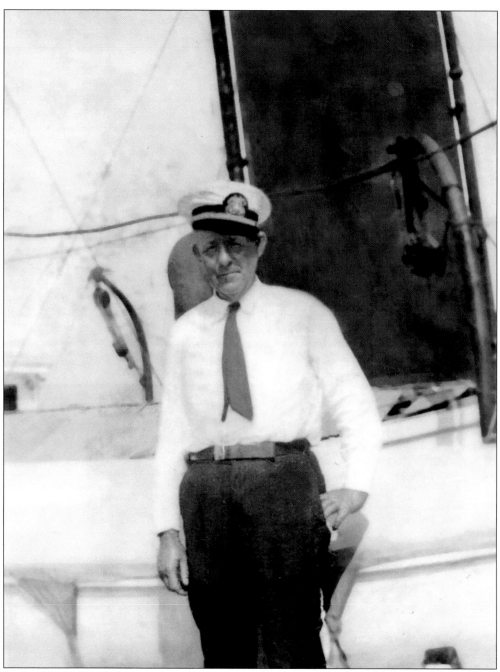

During World War II, Robert Henry Spencer was the head lighthouse keeper at the Georgetown Light. He took over as captain, as all main keepers were called, in 1939 and remained there until 1947. Captain Spencer is shown in the above picture on his government boat, *The Palmetto*. (Courtesy of the Spencer family album.)

This is Robert Henry Spencer's wedding-day picture from 1906. His wife was Ivy Lena Vick. (Courtesy of the Spencer family album.)

Capt. Robert Henry Spencer and his son Aldon are pictured in 1943.

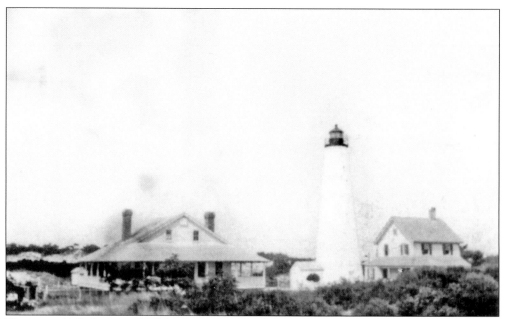

This is a c. 1943 photograph of the Georgetown Lighthouse compound. On the left is the assistant keeper's dwelling. On the right is the head keeper's house. It had eight rooms. In the center of the photograph is the lighthouse and the cistern. The cistern was a receptacle for catching and holding rainwater. The water was then given to the animals and was used for doing laundry. (Courtesy of the Spencer family album.)

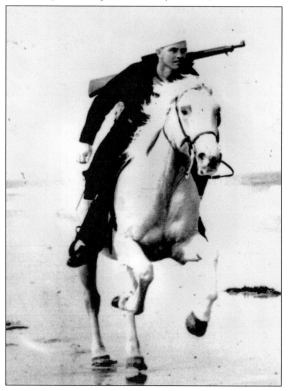

The Coast Guard Beach Patrol was active during World War II. Mounted guardsmen patrolled the beach of North Island throughout the war. They lived in navy barracks on the island, but they were separated from civilians on the beach. Civilians could, however, ride their horses with permission. All South Carolina beaches were patrolled during the war. Some were patrolled by dog patrol. Charleston had picket patrol to guard the harbor entrance and the port leading to the Charleston Navy Yard. (Courtesy of U.S. Coast Guard.)

Geraldine "Jerry" Spencer Hall of Charleston has fond memories of life on North Island during World War II. As a teenager, she enjoyed riding the U.S. Coast Guard's horses. The guardsmen lived in barracks on the island. She recalls times when her family entertained the guardsmen; however, Jerry and her sister were not allowed to socialize with the guardsmen unless her parents were around. In this photograph, two of Jerry's classmates are seen fraternizing with the "Coasties," as the guardsmen were called. The girls are identified as Jane Causey (left), from Charleston, and Frances Brewington (right), from the Allendale Plantation. The guardsmen are unidentified. (Courtesy of the Spencer family album.)

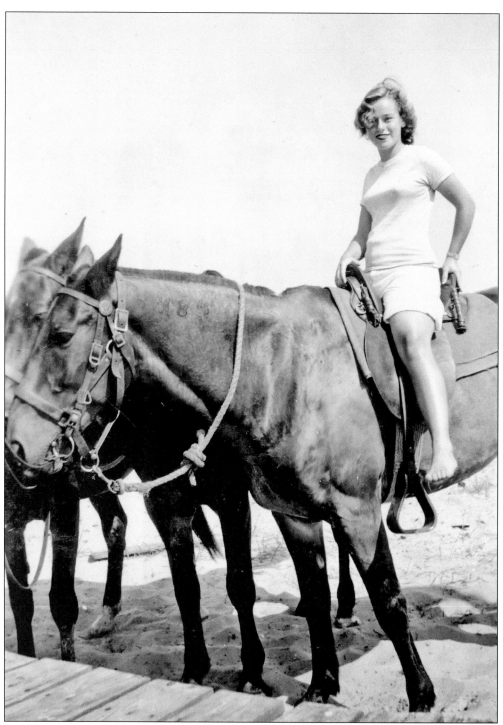

Jerry Spencer is seen here riding Lightening, one of the Coast Guard's horses. The horses were kept in a corral but were allowed to come up to the pier of the compound during the day. Lightening seemed to know that Jerry considered him her favorite horse and would come to the pier and wait for her. (Courtesy of the Spencer family album.)

Robert Spencer, a son of lighthouse keeper Robert Henry Spencer, spent much of his time catching fish on North Island. (Courtesy of the Spencer family album.)

Aldon Spencer, youngest son of Robert and Ivy Spencer, cleans fish near the pier. Note the boathouse in the background. (Courtesy of the Spencer family album.)

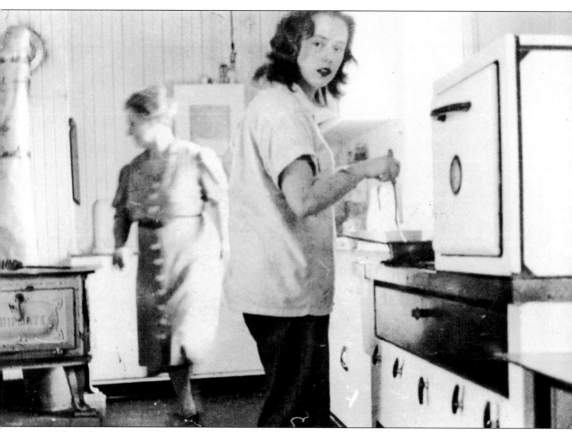

This photograph of Ivy Spencer and her daughter Jerry was taken in the lighthouse kitchen. On the left is a coal and wood stove. To the right Jerry stirs food on the eye of a kerosene stove. There's a small sink behind Ivy. (Courtesy of the Spencer family album.)

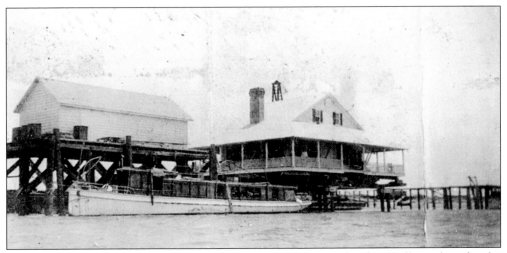

In this photograph, a house is being brought in on a barge to be the dwelling place for the assistant lighthouse keeper. Later it was decided that the house was haunted. The keeper and his wife often heard the sound of chains being dragged across the upstairs floor. Many mornings they found that the pictures on the upstairs walls had fallen during the night. (Courtesy of the Spencer family album.)

Ludwig "Ludie" Munn was the assistant keeper at North Island during World War II. Munn served with the Lighthouse Service from 1918 to 1947. His places of service included Cape Romain, Hunting Island, Sullivan's Island, and the Georgetown Light. (Courtesy of the Spencer family album.)

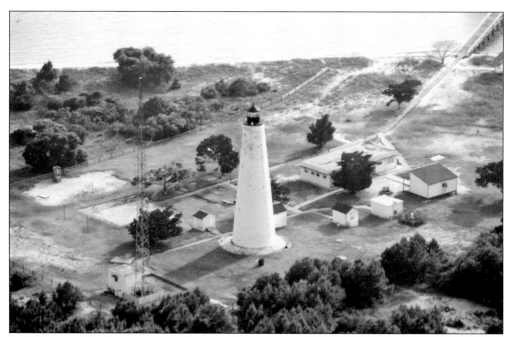

In 1988, the S.C. Department of Juvenile Justice used North Island for a rehabilitation and detention center for firs-time, nonviolent offenders. New barracks were built for the center. The center was discontinued in the early 1990s. (Courtesy of Ernest Ferguson.)

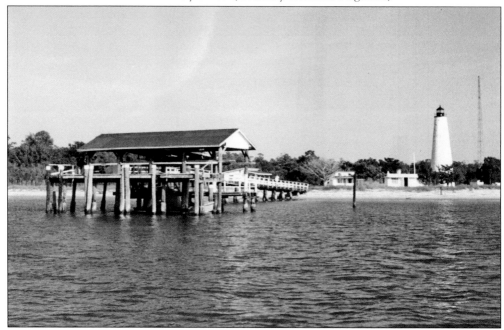

This photograph shows North Island in 2001. The lighthouse was manned until 1986. In 1989, the light survived Hurricane Hugo without damage, but the electricity went out. In 1999, a solar-powered lens was installed. The fifth-order lens dating from 1867 is now displayed at the U.S. Coast Guard station in Georgetown. The light still shines every night as a navigational aid to seafarers entering the harbor. (Courtesy of Donald Edney.)

Three

CAPE ROMAIN LIGHTS

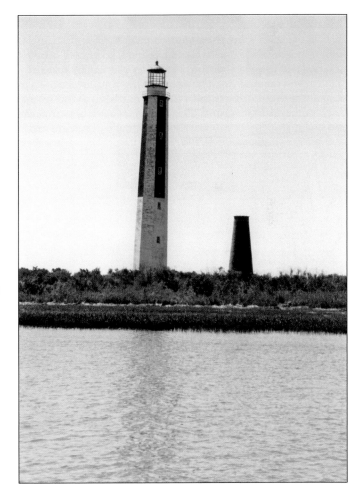

Seven miles offshore of McClellanville on Lighthouse Island at Cape Romain stand two lighthouses that guided mariners past dangerous shoals. The first was built in 1827 and has been inactive since 1858. The second replaced the first in 1858, but it was deactivated in 1947, after World War II. The first tower was 65 feet tall and was made in the round, old-style, brick manner. It has no lantern room. The second is 150 feet tall with a lantern and galley. It leans slightly. (Courtesy of Margie Clary.)

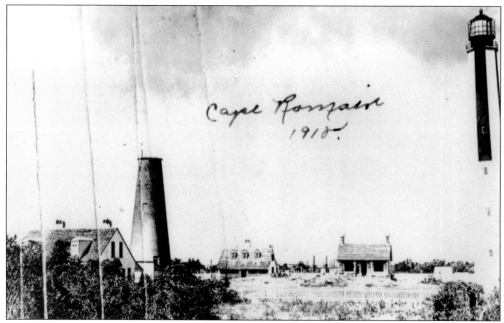

From a keeper's point of view, an assignment to Cape Romain was isolating and lonely. The closest town, McClellanville, was a small fishing village, and the island was desolate, with only forests and wild animals. There was no social life except for monthly trips to the mainland for supplies. Fishing, reading, and hunting were the only pastimes with which a keeper might amuse himself when not occupied with duties. Dangerous shoals stretched into the Atlantic Ocean from Cape Romain, and mariners hugged the coastline to avoid the powerful northeast Gulf Stream. The keeper's house had two apartments downstairs for the assistants, while the second floor was for the keeper and his family. (Top courtesy of U.S. Coast Guard; below courtesy of the Village Museum.)

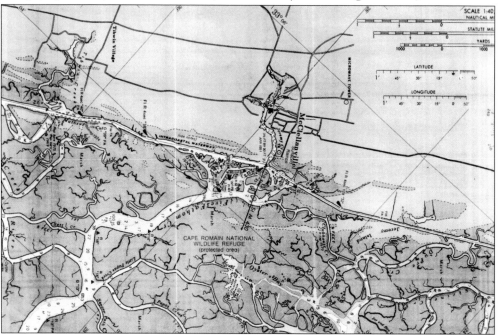

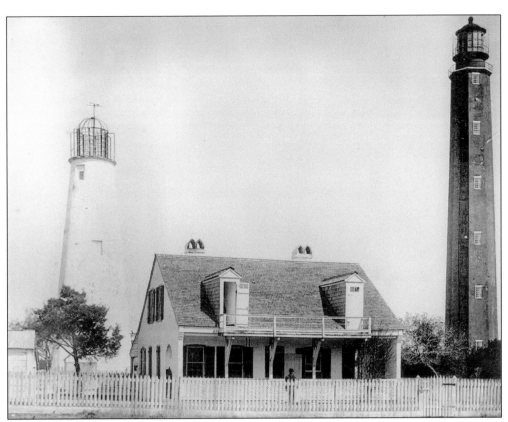

The original tower used the reflector system invented by Winslow Lewis. It was based on the Argand lamp used in Europe, but it proved unsatisfactory and was replaced by a parabolic reflector and 12 whale oil lamps in 1847. When the new tower was erected, slave labor was used. One hundred ninety-five steps spiraled up the inside walls. It was equipped with a first-order Fresnel lens. A keeper had to be in excellent physical condition to climb the stairs, rescue stranded mariners, and make repairs to the station. (Both courtesy of Antique Photos of Beaufort.)

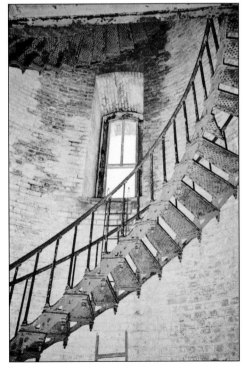

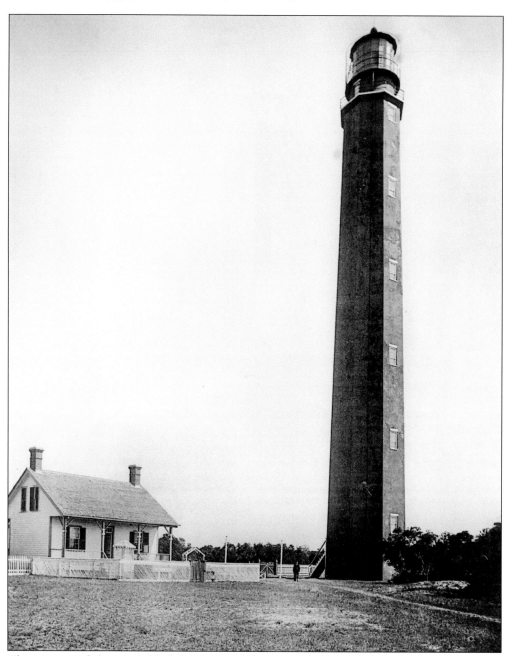

This picture of the second lighthouse was taken on June 6, 1885, by Maj. Jared C. Smith. Halvor Svendsen Sr. was the second assistant at Cape Romain in 1897 before transferring to Bull's Island. U.S. Coast Guard records indicate that some of the first S.C. female assistants and later the first female keeper, Louise M. Johnson, worked both here and at Hunting Island. Records are somewhat unclear because of the Civil War, but Anton Johnson was the keeper at Hunting Island in 1859 with his wife, Mary. When the newer light was deactivated in 1947, the keeper's quarters were torn down. In 1980, the Cape Romain Lights were put on the National Register of Historic Places. (Courtesy of U.S. Coast Guard.)

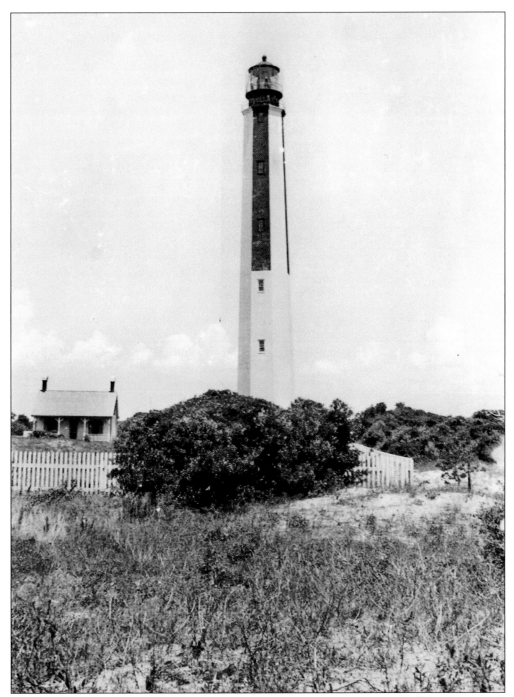

Pictured about 1947, the original, deactivated tower was painted red as a landmark. When the second, tall, octagonal tower was in use, it was painted alternating black and white on the upper half and solid white on the bottom half. A young man of Prussian descent, August Wichmann, became an assistant keeper in 1906. Next he served as the keeper at Hunting Island, but Wichmann returned to Cape Romain as its keeper in 1913, serving until 1934. (Courtesy of the Village Museum.)

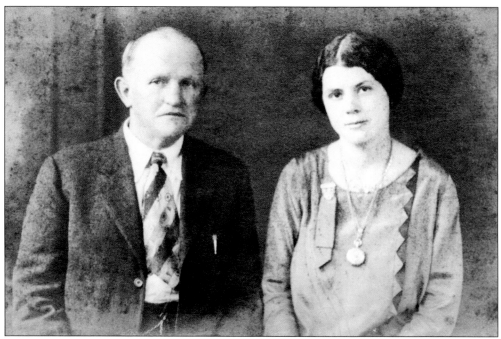

Pictured are Capt. August Wichmann and his wife, Lady Hazel Ruth Wichmann. August Wichmann worked at the Cape Romain Light for 20 years. Before that, he served in Cuba as a sergeant with the U.S. Army during the Spanish-American War. Residents of McClellanville recalled that he could climb the 196 steps of the lighthouse like a young man, even when he was 50 years old. (Courtesy of Fred Wichmann.)

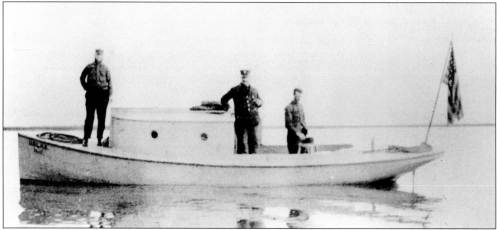

Lighthouse keeper August Wichmann (pictured center, in boat) returns to Cape Romain in a U.S. Coast Guard tender that had a one-cylinder, Kermat, eight-horsepower, hand-cranked engine. To go forward, the crank was turned clockwise. To go astern, the engine had to be stopped, and then the crank was turned counterclockwise. Wichmann's son Fred loves to tell the story of his own birth at Cape Romain. Dr. McClellan had come from the village to help with the delivery and brought a woman named "Mammy Hessie" with him. They stayed up all night waiting for Fred's birth. Finally, the keeper and the doctor went to fish. Coming back up the dock, August Wichmann held up a 30-pound bass and shouted to Hessie at the window, "Look what I caught!" Hessie held Fred to the window and replied, "Look what I caught!" (Courtesy of Fred Wichmann.)

Lady Hazel Ruth Wyndham met August Wichmann when her Sunday school class picnicked at Cape Romain. Their son Fred Wichmann is now a well-known Charleston realtor who grew up at Cape Romain. Fred remembers that his father also raised cattle on the island. Butchers came from Charleston to bid on them, and Ruth would milk a few cows. They also had turkeys until one pecked Fred. During August's first year as keeper in 1913, the U.S. Coast Guard gave Wichmann a sailboat so he could fetch supplies from the mainland. It leaked so much that he bought his own boat for $25. Pictured below, Capt. August Wichmann's granddaughter Laura Hipp and her husband, Preston, visit Cape Romain. (Both courtesy of Laura Wichmann Hipp.)

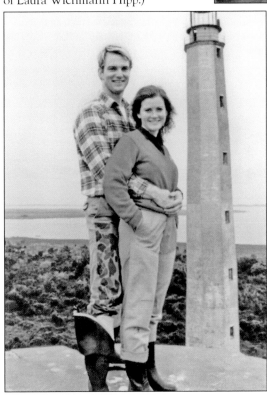

In the early 1900s, Cape Romain parties were popular with the residents of McClellanville. They would go to the island on ferries like the *Virginia Belle* for all-day picnics, evening bonfires, and oyster roasts. Southern fried chicken, ice-cold watermelon, homemade pickles, tomato sandwiches, and apple pie were just some of the fare served at cape parties. (Both courtesy of the Village Museum.)

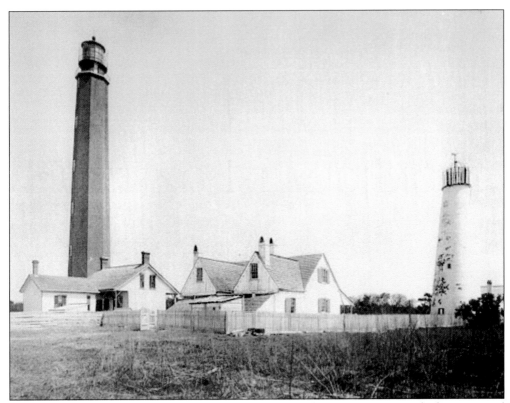

Part of the Cape Romain National Wildlife Refuge, both towers are in need of repairs, and their disappearance would leave the landscape disturbingly empty. The lighthouses represent a lifeline, a steady beam in the raging storms. Continued effort must be made to preserve these romantic reminders of maritime history. Private boat tours are provided by the Sewee Visitor and Environment Education Center in Awendaw. (Courtesy of the Village Museum.)

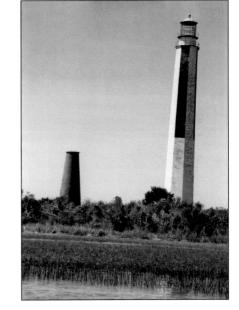

The first tower, built in 1827, was only 65 feet tall and was found to be inadequate for lighting the shore. In 1857, a new tower was erected; it was a 150-foot, pyramideal tower with a staircase of 195 steps. The old lighthouse stands nearby like an abandoned chimney. (Courtesy of Margie Clary.).

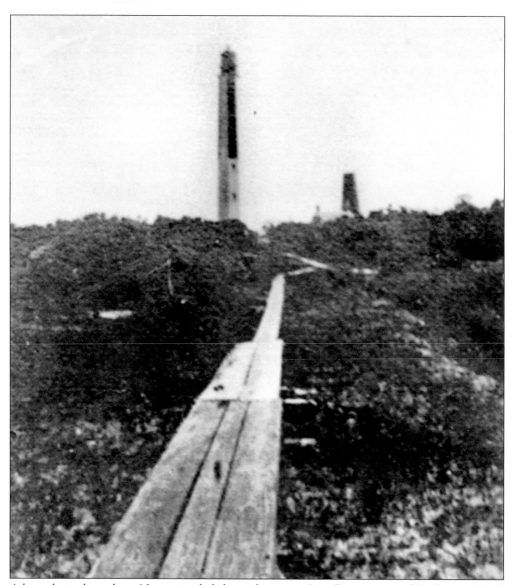

A legend circulates that a Norwegian lighthouse keeper at Cape Romain named Fischer murdered his wife because she wanted to return to Norway for an extended stay. Supposedly, he passed her death off as a suicide, but he later confessed to the murder on his deathbed. There is no record of a Fischer ever serving as a keeper at Cape Romain, although the Charleston *News and Courier* of April 6, 1937, does tell of a suspicious death that occurred on the island. In the summer of 1896, the keeper Captain Johnson (also spelled Johansen) from Norway had a wife who received a sum of money and a box of jewelry. One day it was reported that she had committed suicide, a fate not that unusual among keeper's wives whose lives were often isolated and lonely. Those who held the inquest into her death passed the case off as a suicide even though Mrs. Johnson was almost decapitated. Captain Johnson resigned soon after, and it is believed that he tried to make a confession at his death but that it was unintelligible. Her grave is marked by a low fence on the island's northern end. Captain Johnson probably took the valuables with him when he left, although some people in McClellanville believe the jewelry box may be buried on the island. (Courtesy of the Village Museum.)

Four

HUNTING ISLAND LIGHT

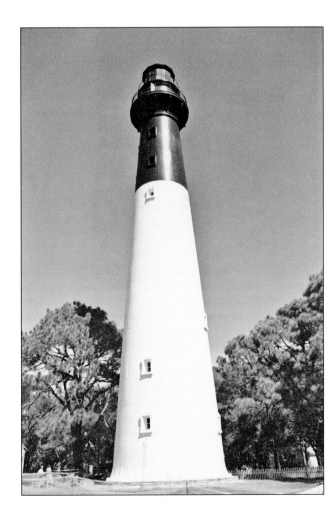

The original lighthouse at Hunting Island, built in 1859 on what is today Hunting Island State Park, served as a navigational aid for captains transporting cotton, indigo, and rice from plantations between Charleston and Savannah, Georgia, to Europe and bringing furniture, fine china, and silk from markets around the world. (Courtesy of Michael Willis.)

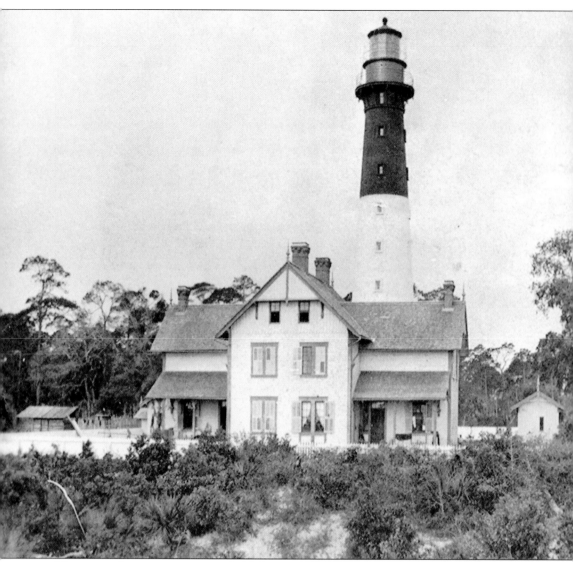

The original tower was a conical, 95-foot tower of red brick with a brass lantern. It held a second-order, revolving Fresnel lens that flashed every 30 seconds. It could be seen for 17 miles, but it was destroyed by the Confederacy during the Civil War. The replacement light was built in 1875, a $102,000 project. Shown above, it boasted a station that housed a keeper and two assistants in an impressive three-story building. (Courtesy of the Caroliniana Library, University of South Carolina.)

The genius of the 1875 tower was that it was movable, and due to erosion, in 1889, it was disassembled and moved about 1.25 miles south of its original location. The keeper's station and outbuildings included an oil shed and storage buildings. The relocation cost $51,000, much less than the cost of totally rebuilding the light and accompanying structures. A boathouse, dock, and tram were built to transport kerosene to the new location. (Courtesy of U.S. Coast Guard and the Village Museum.)

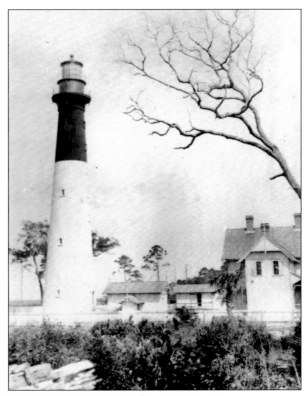

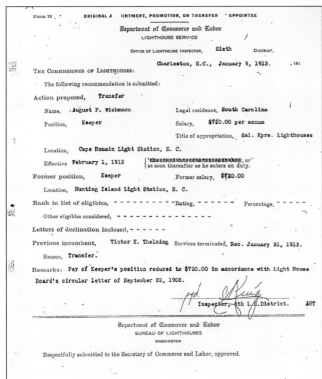

This contract from 1913 shows a light keeper's per annum salary. (Courtesy of the Beaufort County Library.)

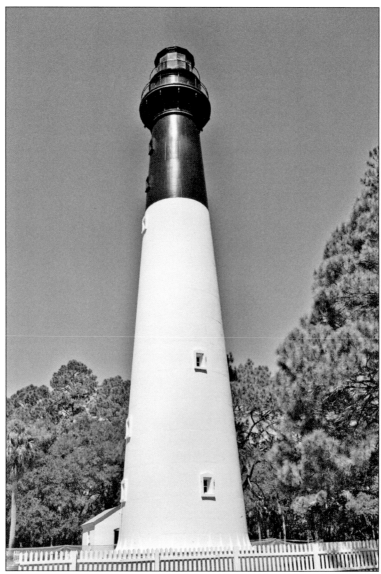

An 1860 census of Hunting Island listed seven residents: Anton Johnson, 30 years old, born in Germany, lighthouse keeper; Mary Johnson, 25 years old, lighthouse keeper; William Bennett, 27 years old, born in Ireland, lighthouse keeper; Ann Bennett, 22 years old; Rich Egan, 35 years old, born in Ireland, lightship; James Egan, 31 years old, born in Ireland, lightship; James Alford, 40 years old, born in China, no profession given. Early in the Civil War, the Union took charge of coastal plantations, including about 4,000 acres of land, which had been abandoned by fleeing Confederates. A civil engineer, Edward Philbrick came to the Port Royal area with plantation superintendents from the North to help the freed slaves. When the government auctioned the land for delinquent taxes, Philbrick purchased several plantations. In an 1863 letter published in the book *Letters from Port Royal: 1862–1868*, Philbrick said he had visited Hunting Island and had seen the ruins of the lighthouse. He wrote, "There is nothing left now but a mass of bricks and rubbish about forty feet high. It was blown up by the rebels at the beginning of the war. The keeper's house has been all torn to pieces by the negroes for rebuilding their own cabins and corn houses." (Courtesy of Michael Willis.)

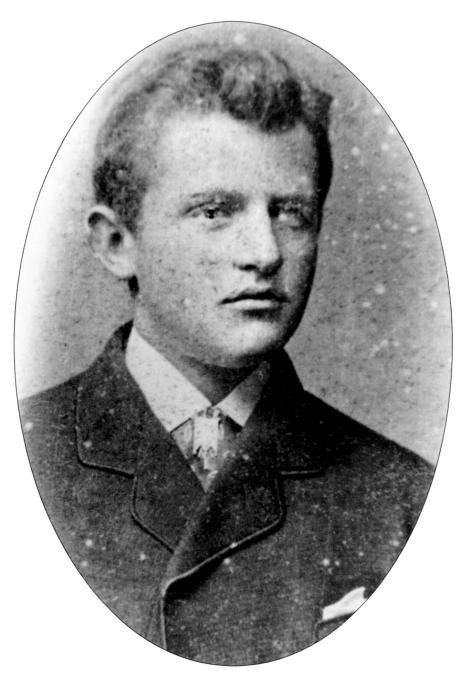

The 13th keeper at Hunting Island was August Wichmann, who had also served as a keeper on Cape Romain. His son Fred recalls that his father said supplies were delivered from the river to the station by tram. Monthly trips were made to Beaufort. This involved rowing to St. Helena, where Wichmann kept a horse to ride to town. Since Hunting Island was originally a game area for hunting by local plantation owners, the keeper was able to shoot wild hogs and deer. Once, a 10- to 12-foot-long alligator approached Mrs. Wichmann as she was hanging out the wash and opened his mouth. August killed it with an ax. Also, a wildcat ate the Wichmanns' chickens until the keeper shot it. (Courtesy of the Fred Wichmann.)

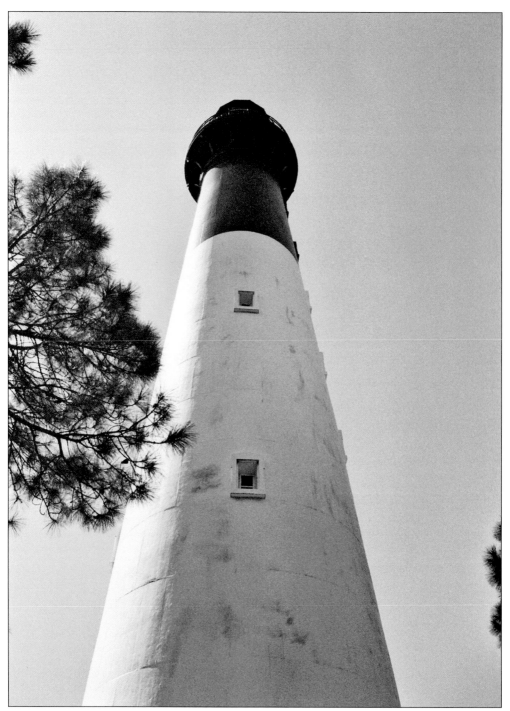

Fred Wichmann, a Charleston realtor, recalls that his father worked the lantern room nonstop for three days during the hurricane of 1913. August Wichmann was temporarily blinded by the work but made a full recovery. This type of relentless dedication gave light keepers their reputation for courage. In 1908, at the age of 39, August received a salary of $700 per year. He later transferred to Cape Romain. (Courtesy of Michael Willis.)

Today the former oil shed houses historical displays. The lighthouse was decommissioned in 1933 and was replaced by a lighted whistle buoy. It is still a landmark for boaters on the Intracoastal Waterway. As a part of Hunting Island State Park, the lighthouse can be toured, and guests can climb to the top for a crow's-nest view. Guided tours are available. The keeper's house burned in the 1930s, but the foundation has been uncovered. (Right courtesy of Margie Clary; below courtesy of Michael Willis.)

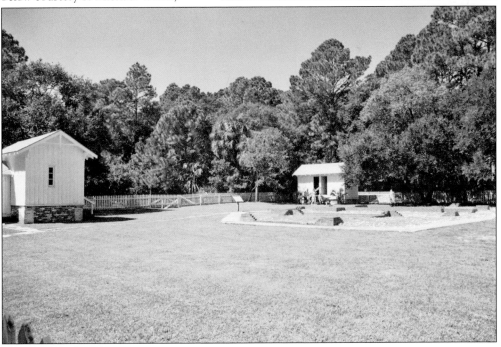

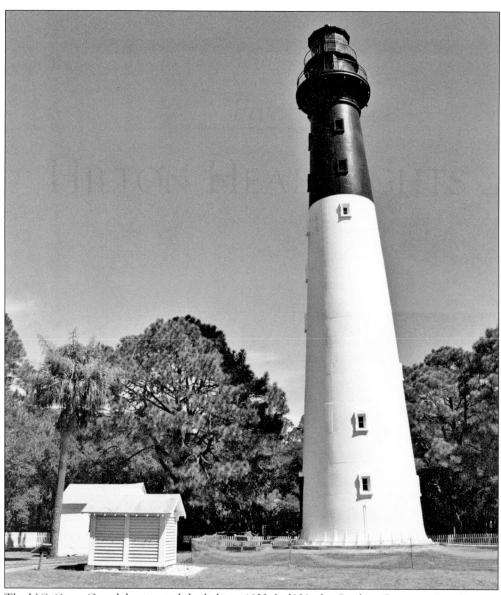

The U.S. Coast Guard deactivated the light in 1933. In 1938, the Civilian Conservation Corps, a New Deal, work-relief program by President Roosevelt, began work on the state park. The corps built a bridge, and the workers were housed in the keeper's house before the fire. During World War II, the U.S. Army Air Corps used the tower as a radio station. In 1942, the coast guard used it to protect the coastline. The park was not opened again to the public until the war was over. On May 26, 2005, the lighthouse reopened after being closed for 22 months of repairs. Merchant Ironworks of Sumter completed the $114,000 job on the interior steel steps. One visitor called the lighthouse, "one of South Carolina's greatest pearls." Efforts through groups like the Friends of Hunting Island work to ensure that ongoing erosion does not destroy the island and supports beach re-nourishment projects by the government. The Hunting Island State Park serves as a preserve for wildlife, and visitors can enjoy more than four miles of beach, a maritime forest, and a saltwater marsh. Both cabins and camping facilities are available. Contact the S.C. Department of Parks, Recreation, and Tourism for more information. (Courtesy of Michael Willis.)

Five

HILTON HEAD LIGHTS

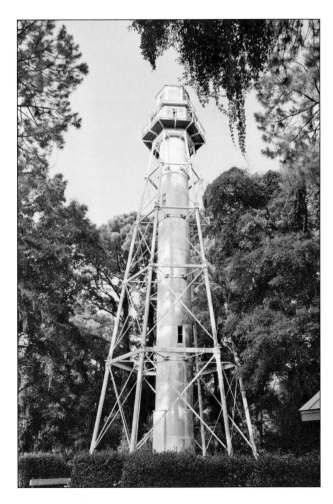

It is recorded that Union soldiers built the first lighthouse on Hilton Head Island in 1863. During a storm in 1869, the small tower was destroyed. (Courtesy of Michael Willis.)

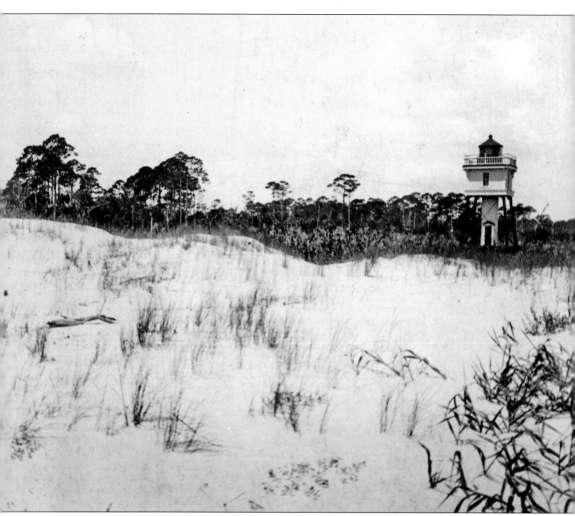

In 1877, a light station was established on the eastern side of Hilton Head Island. A pair of range lights were built and lit in 1880. The picture shows one of the range lights. The second range light was placed atop the keeper's dwelling, much like Haig's Point Light. They were completed in 1880 but were not lit until 1881 due to the fact that nearby Parris Island was building two range lights. The four lights were to work in connection with each other to guide vessels entering the harbor at Port Royal. On August 1, 1881, all four range lights were lit for the first time. An additional range light was built on Hilton Head Island in 1898. (Courtesy of U.S. Coast Guard.)

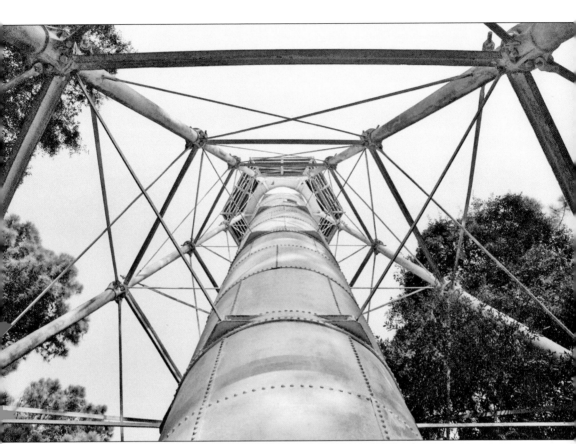

The largest rear light was the Hilton Head Light. It was a six-legged skeletal tower with a cypress lantern room and was fitted with a reflector light. The structure was made of cast iron, and the tower was 94 feet tall. The principal series of columns rested on a concrete foundation that was 6 feet thick and were bolted down. It has a central cylinder surrounding the 112-step spiral staircase. This is the same structure that stands today. Additional land was bought in 1891 and added to the light station. A brick oil house was built in 1892. (Courtesy of Michael Willis.)

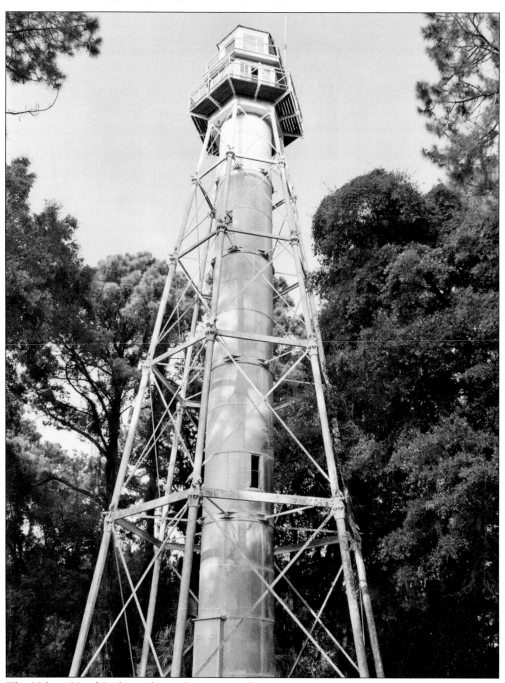

The Hilton Head Light withstood numerous hurricanes and storms in its early years. It also survived the earthquake of 1886. A story is told that the keeper was in his quarters when the first shock struck. By the time the second shocks arrived, he was in the lighthouse. He rode out the quake there. He said, "The whole tower shook and heaved like a small boat in a heavy sea." The lighthouse was not notably damaged. His wife and daughter did not notice the earthquake much. They thought it was only the resident ghost giving them a shake. The legendary ghost is referred to as "The Lady in Blue." (Courtesy of Michael Willis.)

During World War II, U.S. Marines set up Camp McDougal around the range light. The tower was used as a lookout for German ships and UT boats. During this time, the first road was paved on Hilton Head Island. After the base was closed, the tower stood empty for years. It was not until 1950 that modern life reached the island. Electricity was made available to all residents. A ferry started running regularly. A school for the island's black children was opened. One small motel was built. A two-lane swing bridge was built to the mainland. Telephone service did not reach Hilton Head Island until 1960. This is a picture of the encampment around the lighthouse. (Courtesy of Parris Island Museum.)

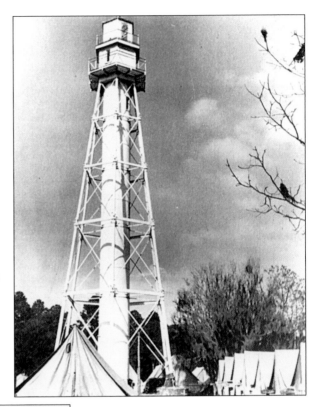

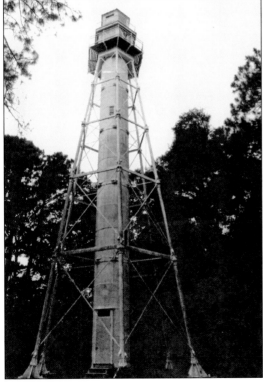

The 1880 lighthouse was built on land that was once a part of the Leamington Plantation. Officially it is called the Hilton Head Range Light; however, many of the islanders call it the Leamington Light. (Courtesy of Greenwood Development Corporation.)

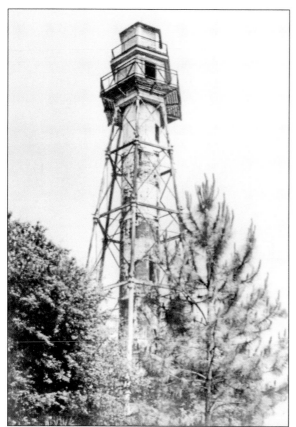

From 1950 to 1985, the lighthouse fell into disrepair. In 1985, the land where the lighthouse stands was purchased for a resort development. The lighthouse now stands among tall pine trees between the eighth and ninth holes of the Palmetto Dunes Resort's Arthur Hills Golf Course. The oil house and the cistern also remain. (Courtesy of Steele Studio.)

The original lantern room still stands, minus a few shingles. The local birds find it a great place to make nests. (Courtesy of Michael Willis.)

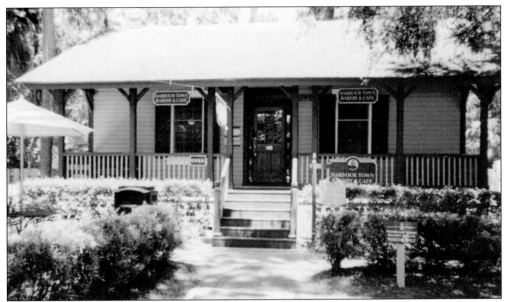

This is a photograph of the keeper's dwelling that once stood at the Hilton Head Light. It was moved to the Sea Pine Resort and has been used as various shops, as well as a bakery. The cottage was first moved from the Charleston Battery in 1880. It had housed lighthouse keepers for the Charleston lighthouse before it was moved to Hilton Head Island. (Courtesy of Margie Clary.)

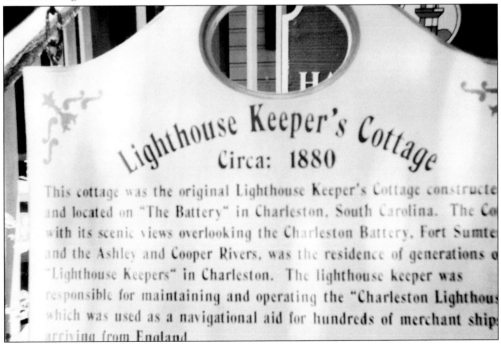

The cottage that once served as lighthouse keeper's home at the Hilton Head Light was first occupied about 1880, according to the sign in front of it. However, before it was moved to Hilton Head Island in 1880, it was built and used as a keeper's cottage on the Charleston Battery. It is said to have housed lighthouse keepers from the Morris Island Light and other waterfront navigational light keepers in Charleston. (Courtesy of Margie Clary.)

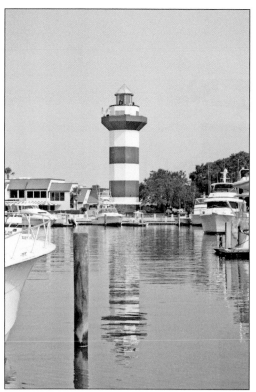

After World War II, Hilton Head Island began to move into the modern age. People from the North purchased land on the island and built summer homes. In 1950, Charles Fraser began to develop the Sea Island Plantation at the south end of the island. It was the first planned community on the island. It became the model for other communities soon to be built on Hilton Head Island. Sea Pines included the Harbour Town marina village, a commercial segment of for the planned community. In 1970, a lighthouse was built in the village, surrounded by galleries, shops, and restaurants. It was never meant to be an official lighthouse but was constructed to serve as a symbol for the Sea Pines community and to memorialize the MCI Heritage gold tournament. The MCI Heritage was first played the year the lighthouse was complete. (Courtesy of Michael Willis.)

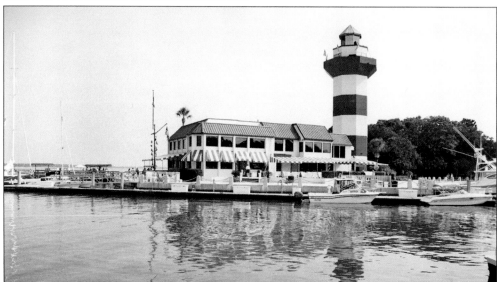

The Harbour Town Light was the first lighthouse to be built by private funds in South Carolina since 1817. The tower is hexagonal shaped and is designed to minimize maintenance because of its protection from saltwater. It stands 90 feet tall. It has an 8-foot concrete foundation and is made of metal lath, plywood sheathing, and stucco. One hundred fourteen steps lead up to the so-called lantern room gift shop and to the observation deck near the top. Although it is not an official lighthouse, its beacon is a navigational aid for boats coming into the island's port. The low-wattage beacon flashes every 2.5 seconds and can be seen 15 miles out to sea. (Courtesy of Michael Willis.)

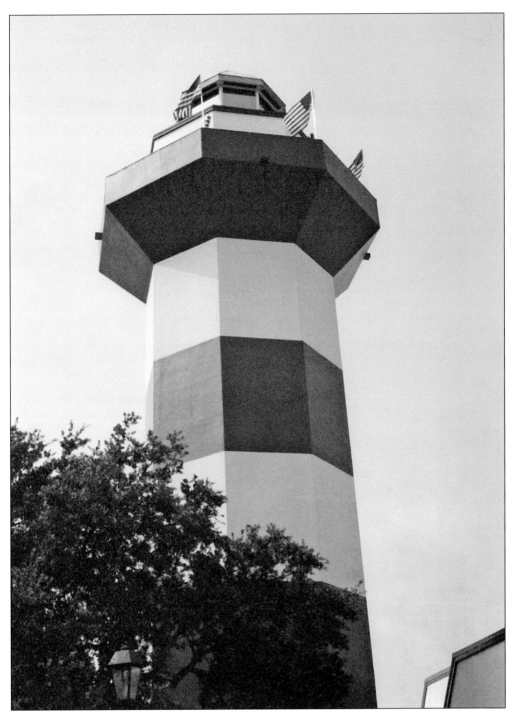

Even though the Harbor Town Light is not an official lighthouse, it is a wonderful replica of a real lighthouse. For a small fee to enter Sea Pines Plantation and an entrance fee of $1, visitors can climb to the observation deck to view the breath-taking Calibogue Sound and the island of Daufuskie. On a clear day, Georgia's Tybee Island Light, 20 miles away, is barely visible. (Courtesy of Michael Willis.)

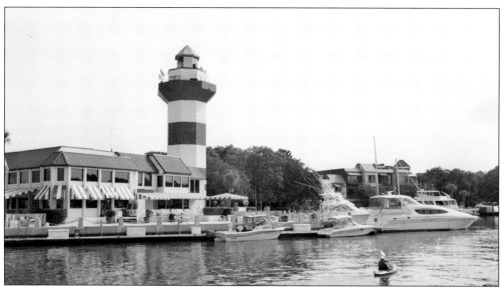

The Harbour Town marina village is a place for tourists to browse shops and eat in restaurants while enjoying the peacefulness of the sea around the island of Hilton Head. (Courtesy of Michael Willis.)

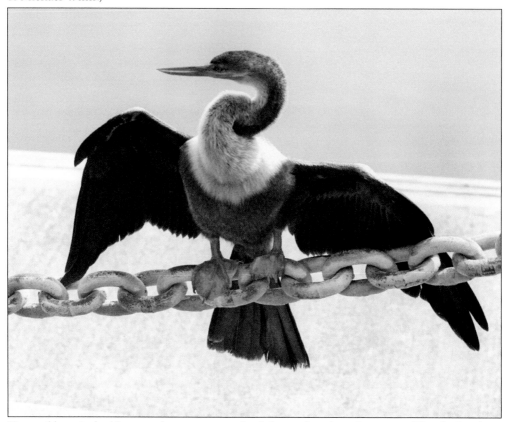

Pictured here is double-crested cormorant seabird that is found on the coast of South Carolina. It can dive 100 feet or more to find its prey. (Courtesy of Michael Willis.)

Six

HAIG POINT

Due to the amount of shipping and passenger service to Port Royal and Savannah, Georgia, navigational aids were necessary to keep the coast safe. In 1854, two separate beacons served as range lights to Calibogue Sound, the waterway that separates Hilton Head and Daufuskie Islands. One was known as the Calibogue Light vessel and was anchored just off the southern tip of Hilton Head Island. The second range light is thought to have been on Daufuskie Island. However, it was not until 1871 that Congress approved plans for range lights on Daufuskie Island. In 1872, land was purchased from the Pope family at Haig Point Plantation. A triangular, 3-acre spot on the northeast corner of the island would house the rear range light. A 2-acre, triangular piece of land south of the rear range property would house the front range light. (Courtesy of U.S. Coast Guard.)

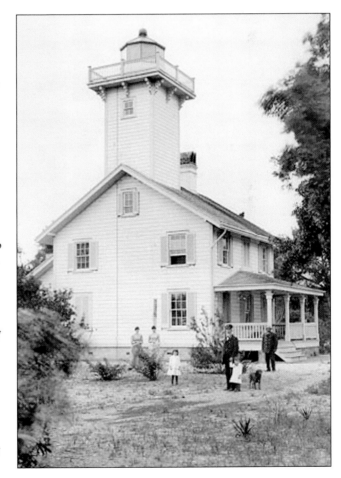

The tower for the rear range light was built on the top of a house. The house would serve as the keeper's dwelling, as well as a lighthouse. The two-story house was built of virgin timber without a single knothole. There were four rooms on the first floor and four rooms on the second floor. The house was built on the site of an 1838 mansion with a tabby foundation. Rather than completely bury the original tabby, the tops of the walls were capped with it. In some photographs, traces of the original foundation can be seen on the grounds. (Courtesy of Margie Clary.)

This is a photograph of the entrance hall in the Haig's Point Lighthouse. Though not visible here, the living room is to the right and on the left are steps leading to the attached tower. (Courtesy of Margie Clary.)

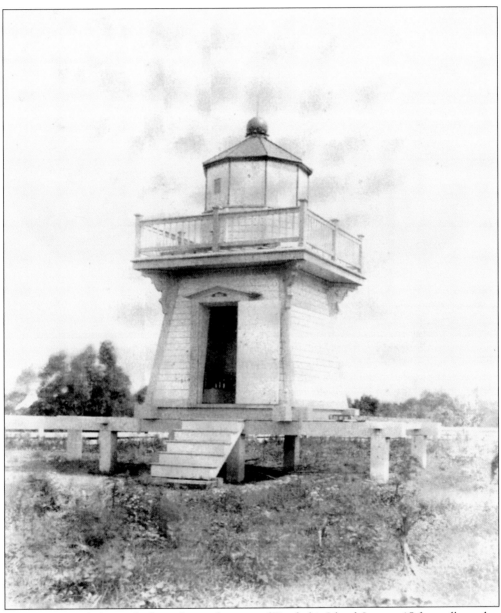

The front range light was built on the southern tip of Daufuskie Island. It was a 15-foot-tall wooden structure that was painted white with lead-colored trim and had a red lantern. Both range lights were of the fifth-order lens with fixed lighting (Courtesy of U.S. Coast Guard.)

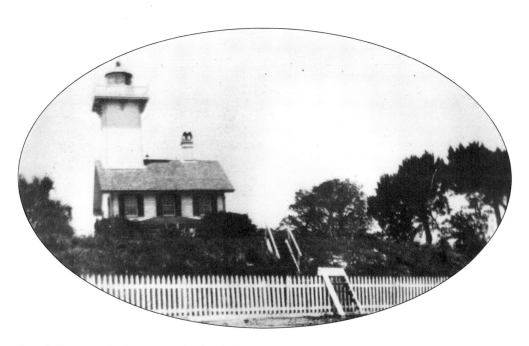

Patrick Comer, an Irishman, was the first lighthouse keeper on Daufuskie Island, pictured here about 1920. He was appointed in 1891 at a salary of $560 per year. His wife, Bridget Comer, was his assistant and was paid a salary of $400 per year. They had one daughter named Maggie. Comer died in 1891, forcing Bridget to leave the island. The second lighthouse keeper, Richard Stonebridge, replaced Comer and remained at Haig Point until his retirement in 1923. (Courtesy of Billie Burn.)

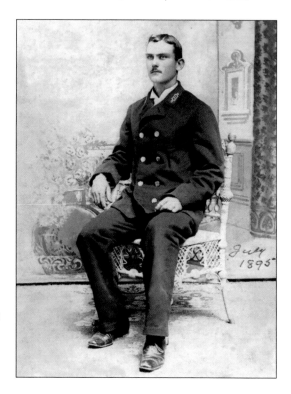

From 1923 to 1924, Charles L. Sisson was the lighthouse keeper. He was the son of Robert Augustus Sisson, who had been the keeper at Bloody Point from 1890 to 1908. Charles then replaced his father as the lighthouse keeper at Bloody Point in 1908. Charles became lighthouse keeper at the St. Johns River Light Station in Florida sometime around 1926. (Courtesy of the Ponce de Leon Inlet Lighthouse Preservation Association.)

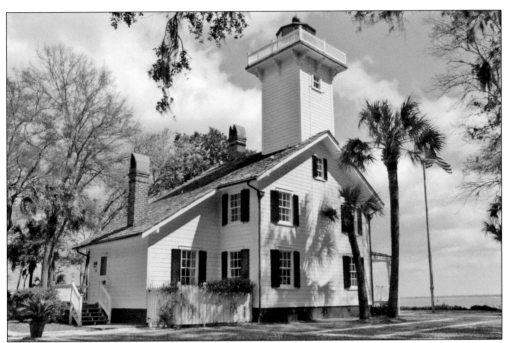

In 1925, the U.S. government sold the Haig Point Light and the five surrounding acres. The lighthouse passed through the hands of several owners in quick succession. In 1930, it was used as a hunting lodge. Several wild parties were held at the lodge. On one occasion a tipsy hunter climbed the tower to the lantern room and leaned against the wooden rail surrounding it. The railing gave way, and he plunged onto the roof and to his death. (Courtesy of Kraig Anderson.)

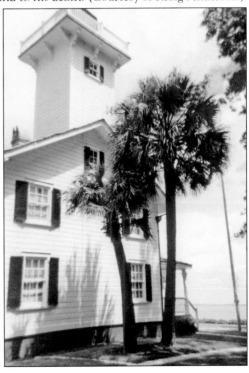

The Haig Point Light fell into disrepair and stood vacant for several years. Shutters sagged, the roof leaked, and all the windows were broken out. In 1965, George H. Bostwick purchased Haig Point Plantation. He set out to repair the desolate ruins of the lighthouse. By 1967, a Beaufort County newspaper reported, "The structure now boasts fresh paint, a new roof, refinished floors, screened windows and other refinements. The glasses in the lamp house have been replaced and the tower is capped with red roof paint." (Courtesy of Margie Clary.)

During the excavation of the Haig Point Light, it was discovered that the lighthouse had been built on the site of a large tabby mansion, originally built in 1838. The house had been destroyed during the Civil War. One of the original fireplaces was discovered. Below the kitchen floor, excavators located the original kitchen. Using the original plans for the dwelling, the lighthouse was scrupulously restored under the direction of Bill Phillips, the lead architect of Colonial Williamsburg. It was completed by October 1, 1986. A see-through panel in the kitchen floor allows visitors to observe the original kitchen's fireplace. (Courtesy of Margie Clary.)

In 1984, the International Paper Corporation purchased Haig Point Plantation with plans to develop a resort community. Today the lighthouse is part of the Haig Point Plantation Resort. Furnished with antiques from the 1800s, it is used as a guesthouse for members of the resort. The original cistern and oil house still stand on the property. The beacon is operational and serves as a private navigational aid to the Calibogue Sound. The Fresnel lens has been replaced by an acrylic lens powered by solar batteries. The beacon flashes for two seconds on and ten seconds off. It can be seen up to 10 miles out to sea. Haig Point is listed on the National Register of Historical Places. (Courtesy of the International Paper Corporation.)

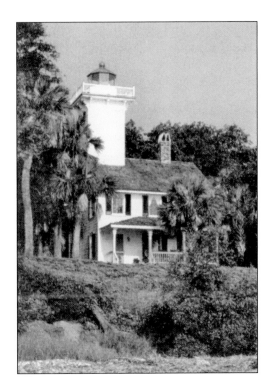

This photograph shows the parlor of the Haig Point Lighthouse. It is decorated with late-1800s furnishings. The Haig Point Resort now uses the lighthouse as a bed-and-breakfast cottage. (Courtesy of Margie Clary.)

Most lighthouses have a resident ghost. The Haig Point Light has one called Maggie. She is supposedly the ghost of Maggie Comer, the only child of Patrick and Bridgett Comer, the first lighthouse keepers. Notice the three rocking chairs on the porch in the picture. It is said that in the late afternoon, visitors will notice one of the chairs rocking back and forth while the others are still, supposedly because of the ghost. Maggie sightings have occurred many times in the house itself. It is not unusual to have visitors calling the resort office in the middle of the night wanting to be moved to another dwelling and saying they will not spend another night in the lighthouse. Along with rocking chairs on the porch, notice a piece of luggage there. The day author Margie Clary visited the lighthouse, the people who had stayed the previous night were leaving because Maggie had kept them up all night. (Courtesy of Margie Clary.)

Seven

BLOODY POINT

In 1881, the U.S. Lighthouse Board felt the need for a set of range lights on Daufuskie Island. The lights would mark the entrance of the mouth of the Savannah River from the Calibogue Sound. A South Carolinian named James La Costa was given the contract to build the main range light. On the southern tip of the island, he constructed a wooden, Victorian-style house with porches across the front. From a dormer window on the second floor, the beacon light was placed and was lit every evening. The light was referred to as the main Bloody Point Light. Bloody Point was named after two massacres that took place on the island during the Yemasee Indian War of 1715. (Courtesy of Kraig Anderson.)

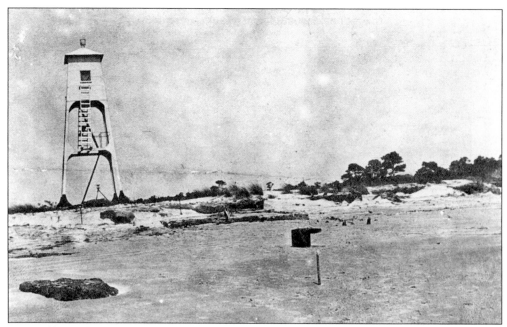

Pictured here about 1922, the second range light was built by John Doyle from Ohio. The tower was made of metal and was 81 feet tall. Every night the light was placed atop of the tower. During daylight hours, it was taken down and stored in a small brick building near the foot of the tower. Both Daufuskie Island Lights were commissioned in 1883. Remains of this tower can still be seen at low tide off the front beach. (Courtesy of Billie Burn.)

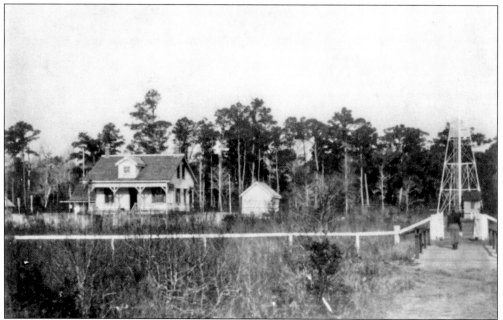

Due to the constant erosion around the front range light, the lighthouses were moved about three-fourths of a mile in 1899. The new site was near the rear range light, and thereafter the Bloody Point house served only as the keeper's dwelling. The white tower to the right is the back range light, which was built by John Michael Doyle in 1883. (Courtesy of Billie Burn.)

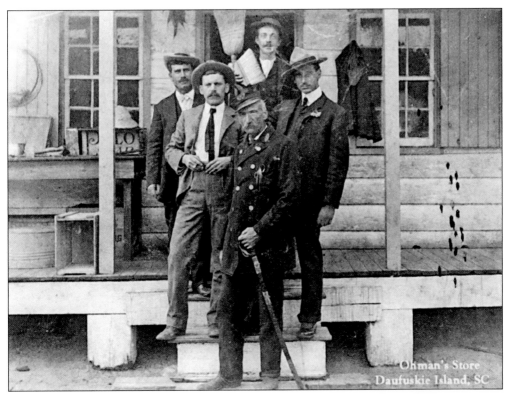

Ohman's Store
Daufuskie Island, SC

Pictured from left to right in this c. 1890 photograph are keeper Robert Augustus Sisson (in front) with his assistants Salvador Lupo, William Dufloque, Yulee Park, and John Wall. (Courtesy of Billie Burn.)

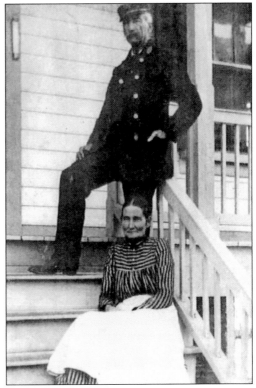

Robert Augustus Sisson, seen here with his wife, Martha, became the light keeper in 1890 and remained there for 18 years. Charles Sisson replaced his father as the keeper in 1908. Charles stayed for only two years, and at one point his father returned to Bloody Point for temporary duty. Gustaf Ohman (also spelled Gustav Ohlman), a native of Sweden, took over as head keeper in 1910. He hired John R. Robertson as an assistant keeper. Robertson resigned in 1913. He was replaced by Arthur Ashley "Papy" Burn Jr. from 1913 to 1914. Ohman served the lighthouse from 1914 until 1922, when it was decommissioned. Other assistants during the 1800s are pictured in the top photograph. (Courtesy of Billie Burn.)

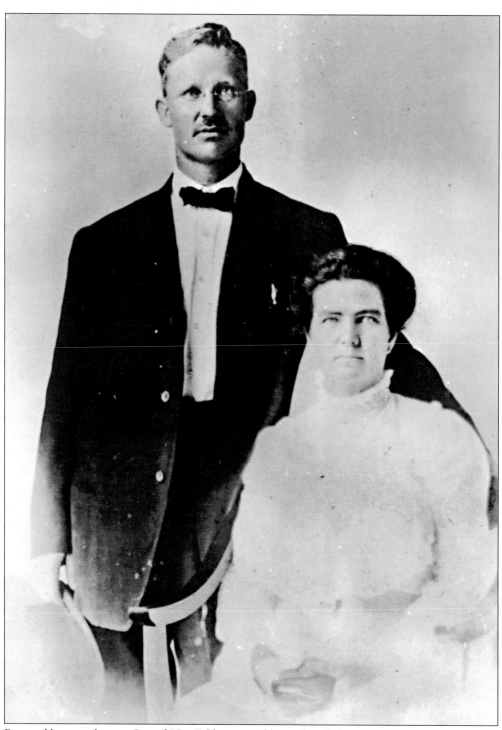

Pictured here are keeper Gustaf "Gus" Ohman and his wife, Edith. Gus was a lighthouse keeper at Bloody Point from 1910 to 1922. Edith became the second postmaster for the Daufuskie Island Post Office from 1915 to 1937. Gus became the third postmaster, working there in 1937 and 1938. (Courtesy of Billie Burn.)

In 1926, Arthur Ashley "Papy" Burn returned to Daufuskie Island and purchased the Bloody Point Light in November 1926. He is quoted as having said, "Daufuskie is the nearest place to heaven as one could find on earth." Burn lived at Bloody Point for 40 years. Although not a drinker himself, Burn set up the Silver Dew Winery in the old lamp building. He made wine from locally grown berries and fruits for his friend and family members. Papy was married four times, outliving three of his wives. He sold Bloody Point in 1966. He died in 1968 while living on Sullivan's Island. His body was brought back to Daufuskie Island for burial in the Mary Dunn Cemetery. (Courtesy of Billie Burn.)

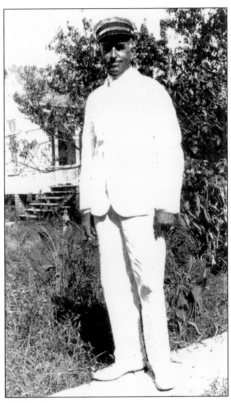

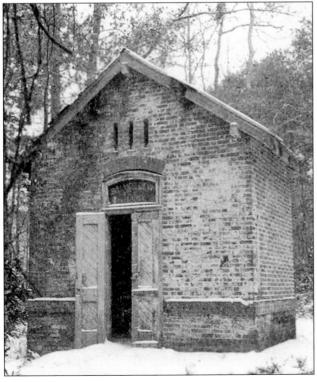

Papy Burn made wine at Bloody Point for more than 30 years. His Silver Dew Winery was set up in the old lamp building. When Joe Yocius bought the lighthouse in 1999, he continued making wine. In 2003, Yocius teamed up with Sunbelt Beverages. Although the wine is no longer made at Bloody Point, it is still sold on the island. (Courtesy of Joe Yocius.)

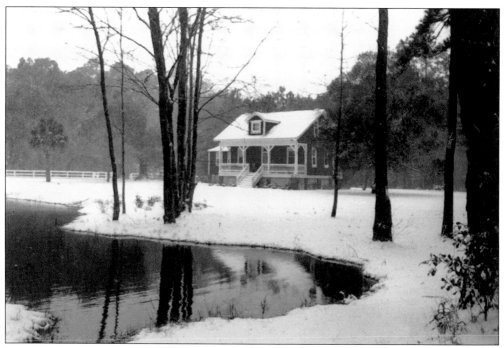

Pictured here in December 1989, Bloody Point enjoys its first white Christmas. (Courtesy of Billie Burn.)

This 1994 photograph shows a view of the back yard of the Bloody Point Light. (Courtesy of Margie Clary.)

Eight

CHARLESTON LIGHT

Commissioned on June 15, 1962, the Charleston Light on Sullivan's Island is the last and most modern tower built by the U.S. Coast Guard. Its shape is unique; it is triangular and made of steel-reinforced concrete covered with aluminum siding. It is air-conditioned and has an elevator in addition to the stairs. The elevator goes to the base of the lantern room and a small ladder continues up to the room itself. The base is used for office space. It stands 140 feet tall, with a focal plane of 163 feet. (Courtesy of U.S. Coast Guard.)

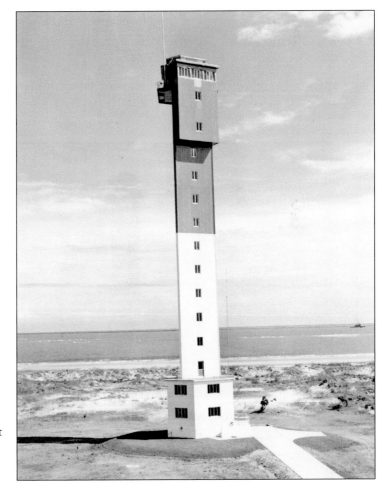

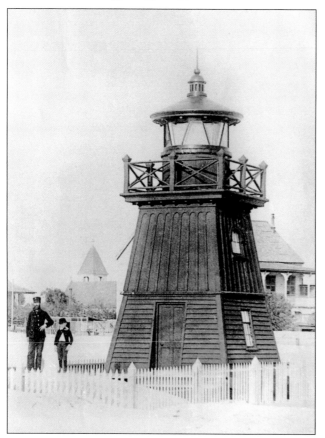

In 1872, range lights were established at Fort Moultrie. The Sullivan's Island rear tower, in l885, was a metal frame structure with a sixth-order Fresnel lens with a red light that contrasted with the front white light, a squat wooden structure in front of the fort. During the Civil War, the lighthouses in Charleston were under the control of the Confederacy and were extinguished to hinder the superior Union navy. On February 17, 1864, Lieutenant Dixon and his crew left Sullivan's Island in the CSS *H. L. Hunley* to attack the USS *Housatonic*. They successfully sank the ship but never returned to Sullivan's Island. Instead the *H. L. Hunley* was lost in the Charleston Harbor until the submarine was finally rediscovered and raised to the surface on August 8, 2000. (Left courtesy of U.S. Coast Guard; bottom courtesy of Kim McDermott.)

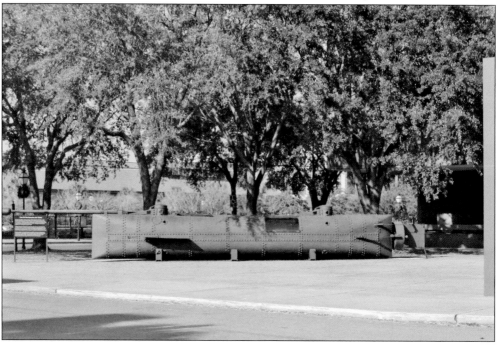

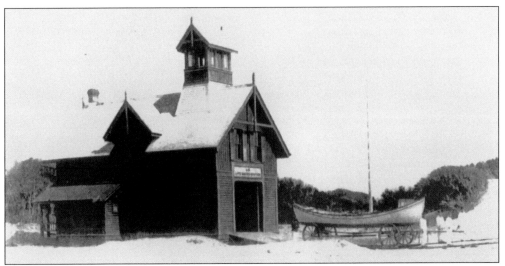

In 1886, a lifesaving station was built on Morris Island, but a diversion of the main shipping channel away from Morris Island and toward Sullivan's Island made this station too remote to assist vessels in distress. The secretary of the treasury was authorized in 1894 to move the station to Sullivan's Island. (Courtesy of U.S. Coast Guard.)

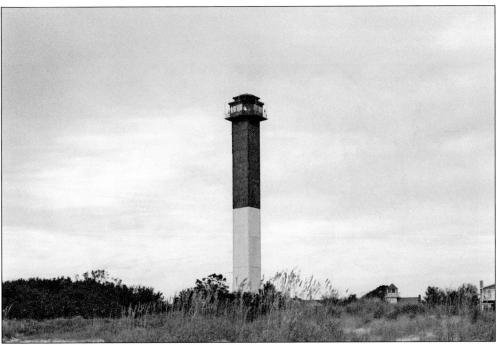

From that first lifesaving station in 1894 to the modern tower, much has changed. Some reports declare that the Charleston Light can be seen 28 miles out to sea. The steel tower even withstood the 145-mile-per-hour winds of Hurricane Hugo in 1989 and is the only lighthouse on the East Coast with an elevator. (Courtesy of Michael Willis.)

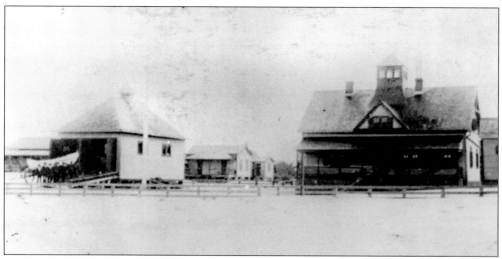

In 1848, the federal government got involved in lifesaving stations after congressman William Newell made a vigorous appeal to Congress for $10,000 to provide for additional surf boats, carronades, and other rescue equipment to stations along the East Coast. The stations were then put under the administration of U.S. Revenue Marine (later called U.S. Revenue Cutter Service). Some of the money at that time helped the Morris Island Station. Later, when the station was moved to Sullivan's Island, more funds were allocated. Pictured above is the keeper's house at the Sullivan's Island Station as it looked when it was built in 1894. Pictured below is the lifesaving service emblem. (Both courtesy of U.S. Coast Guard.)

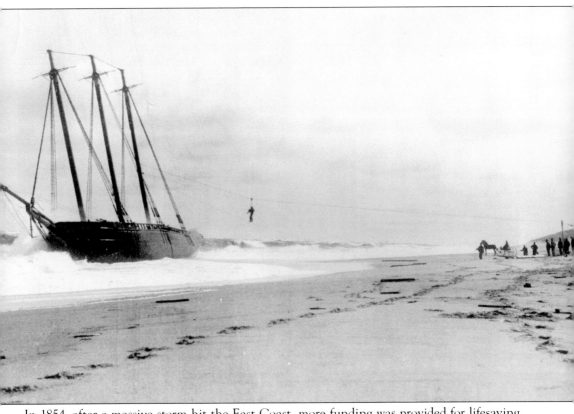

In 1854, after a massive storm hit the East Coast, more funding was provided for lifesaving services. Volunteers still provided most of the manpower, but lighthouse keepers were hired for $200 a year to be on-site. After the Civil War, in 1870, another deadly storm assaulted the eastern seaboard. Newspaper editors called for reform of the lifesaving stations to prevent the loss of life during future disasters. Sumner Kimball, a lawyer from Maine, became chief of the U.S. Treasury Department's Revenue Marine Division. Congress appropriated $200,000 to update equipment and hire more men. The rescue above involved a cannon-like gun (called a Lyle gun) that fired a strong line (or "hawser") to the ship, and passengers were evacuated using a breeches buoy and a hand-crank pulley system. (Courtesy of U.S. Coast Guard.)

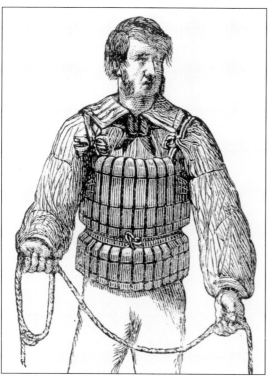

Cork vests were worn to keep rescue workers afloat. (Courtesy of U.S. Coast Guard.)

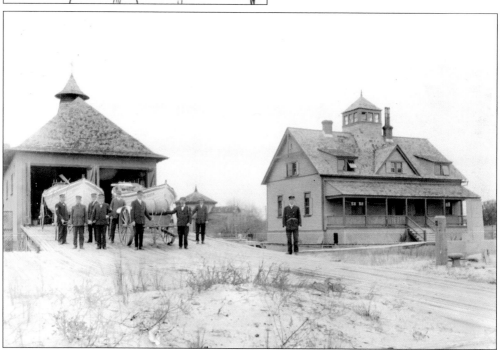

There were three types of stations: lifesaving, lifeboat, and houses of refuge. From November to April was considered the active season on the East Coast. Crewmen had to be strong swimmers, able to launch boats from shore in surf, and were trained in rescue techniques. (Courtesy of U.S. Coast Guard.)

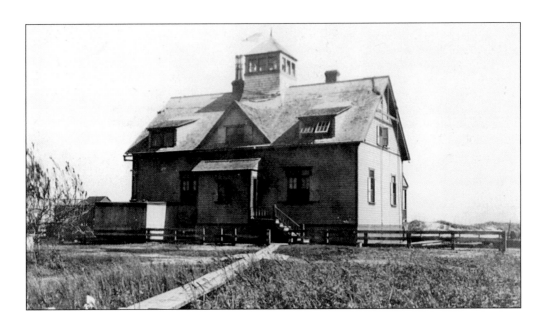

The U.S. Lifesaving Service could rescue those trapped on stranded boats in two ways: by lifeboat or by a hawser that stretched from the beach to the shipwrecked vessel. To propel the hawser to the ship, a Lyle gun shot a projectile carrying the rope up to 600 yards. Once secured, a breeches buoy could be pulled back and forth to evacuate passengers and crew. Surfboats held six to eight crewmen with 12- to 18-foot-long oars. The boat could be pulled on a cart to the shore by horses or by the men themselves. When the U.S. Lifesaving Service established station No. 196 on Sullivan's Island, the Marquette-style station included a dwelling and a boathouse. Capt. John Adams was the first keeper; he was assisted by six crewmen. (Both courtesy of U.S. Coast Guard.)

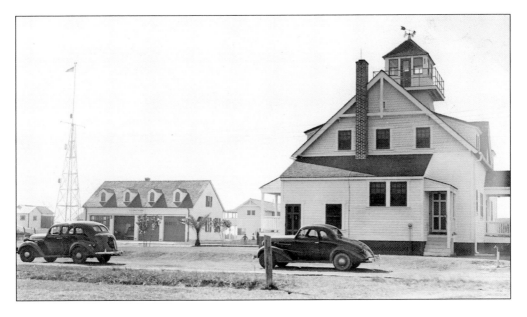

The Sullivan's Island Coast Guard Station, located in what was then called Moultrieville, was first established in 1894. In 1934, the U.S. War Department granted a permit for the construction and operation of a pier, wharf, boat hoist, and boat shelter. With the closing of Fort Moultrie, the lifeboat station was able to add to the existing pier and boathouse. From 1871 to 1914, lifesavers helped 178,741 people. Only 1,455 lost their lives while exposed within the scope of lifesaving service's jurisdiction. According to records, two guardsmen stationed in Charleston lost their lives serving their country; Michael McGuire, who was a surfman, died on patrol on September 4, 1903, and Ernest Moore Jr., a coxswain with the coastal picket *Charleston*, was lost overboard on September 16, 1942. (Both courtesy of U.S. Coast Guard.)

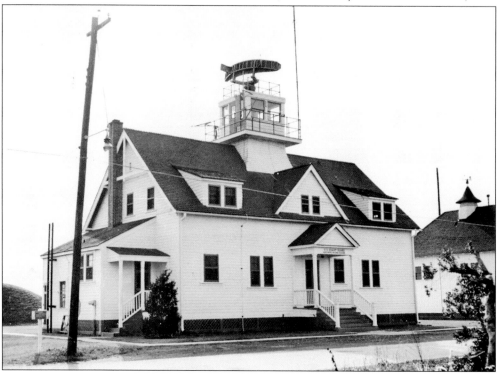

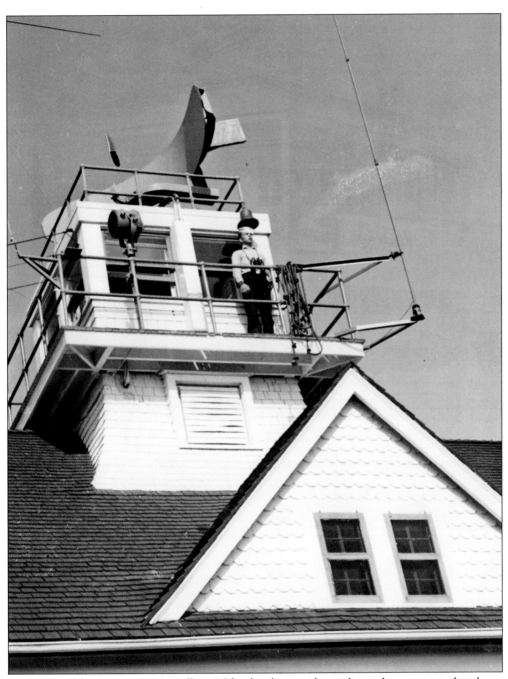

The modern lifesaving station on Sullivan's Island no longer relies on horse-drawn carts and rowboats but on modern powerboats and jet skis. Radar and radio signaling have replaced coston flares and foghorns. In June 1962, the old Charleston Light on Morris Island was decommissioned, and the steel-framed aluminum tower of the new Charleston Light was lit. (Courtesy of U.S. Coast Guard.)

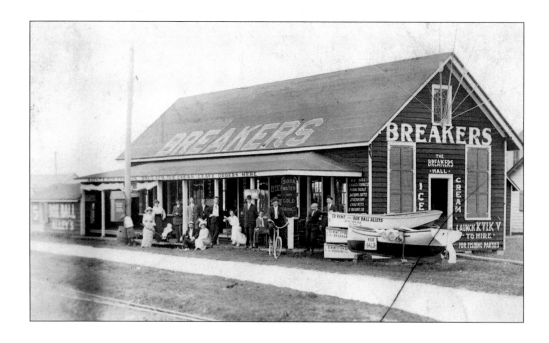

Halvor Samuel Svendsen (on bicycle) was the lifesaving station attendant on Sullivan's Island from 1905 to 1915. He was a descendant of the Svendsens of Bull Island. He also owned a store called the Breakers on Sullivan's Island. The *c.* 1914 postcard above pictures the store. It was written to Carl Olaf Svendsen, keeper at St. Simon in Georgia, from his brother, Halvor Samuel, owner of the Breakers. (Both courtesy Ethel Svendsen.)

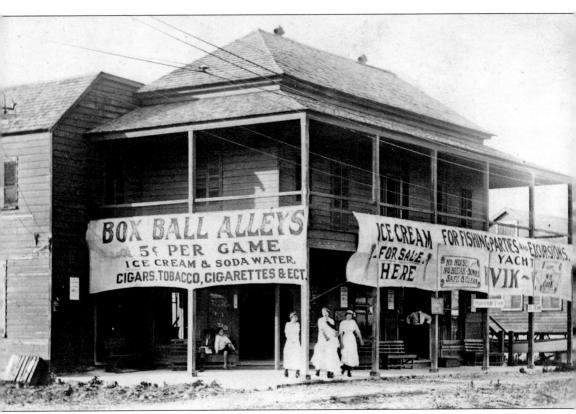

The Breakers was a snack bar and a bowling alley. It was located behind the Atlantic Beach Hotel on Sullivan's Island, then called Moultrieville. It opened in 1920 and is seen here around that time. In 1940, the old building was torn down, and a much larger Breakers building was constructed. Service men and summer residents attended weekly dances at the Breakers. (Courtesy of the Svendsen family.)

Into the 1920s, Sullivan's Island was a quaint, sea island with Victorian-style houses that was only accessible by ferry. No bridge connected Mount Pleasant to Charleston. Ferries dropped off at various landings as is still apparent today in street names like Mathis Ferry Road. Trolleys would then transport passengers to the shore. Charlestonians flocked to the beaches on Sullivan's Island and on the Isle of Palms to escape the heat. Women wearing modest bathing suits or leg-of-mutton sleeved dresses carrying parasols to protect from sunburn strolled the shore with their children. At night, there were bonfires with singing and mandolin playing. A favorite song was "By the sea, by the sea, by the sea, by the beautiful sea." (Courtesy of Irene P. Smith.)

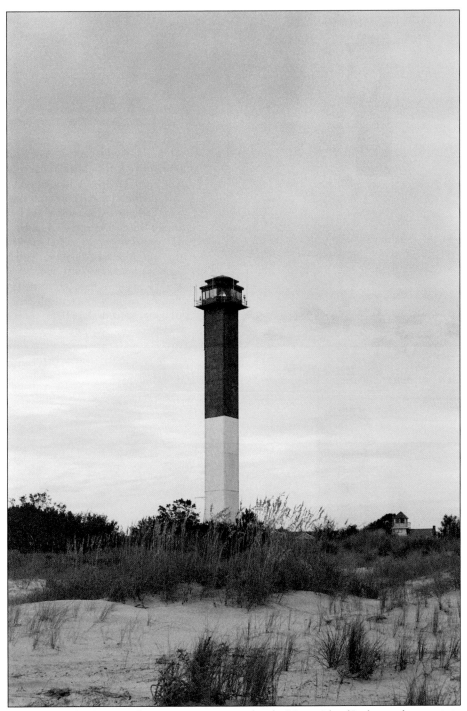

In 1962, the new Charleston Light was put into service after the Morris Island Light was decommissioned. It has two rotating beacons that produce 28-million candlepower. Some have declared it to be the most powerful light in the Western Hemisphere. (Courtesy of Michael Willis.)

With all the latest technology, including its elevator and rotating beacon, the Charleston Light stands watch both day and night, protecting the state of South Carolina. To enter the beacon room, U.S. Coast Guard officers must take the elevator to the 13th floor and then climb a ladder to the top, but the view is spectacular. Unfortunately, the lantern room is only open to official personnel. (Courtesy of Wayne Clary.)

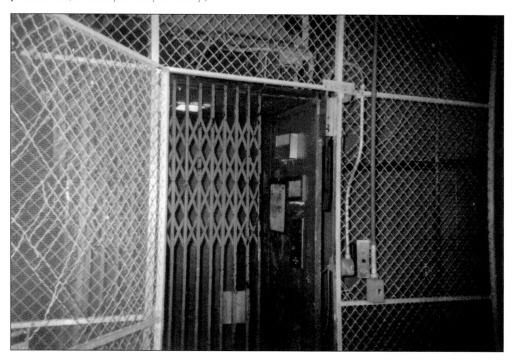

Pictured here is the Sullivan's Island Light as it looks today. It is located not far from Fort Moultrie, where Edgar Allan Poe was stationed when he was in the army. This is also the setting he had in mind when he wrote the award-winning story about buried pirate treasure, "The Gold Bug." Sullivan's Island is also where Stede Bonnet, the gentleman pirate, fled when he escaped from the Provost Dungeon dressed as a woman. He was soon recaptured and, in spite of a letter sent to South Carolina's governor begging for pardon, he was hanged for his crimes as a buccaneer near what is now White Point Gardens on the Charleston Battery. (Both courtesy of U.S. Coast Guard.)

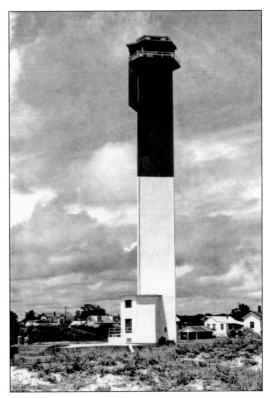

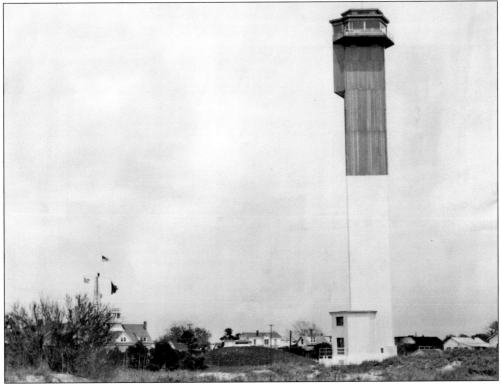

107

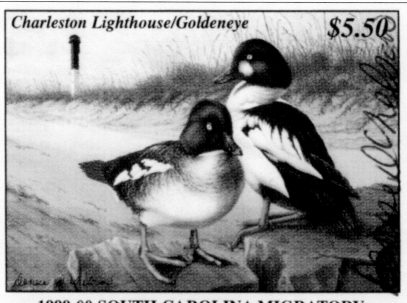

Charleston Lighthouse/Goldeneye **$5.50**

Expires
June 30, 2000

1999-00 SOUTH CAROLINA MIGRATORY
Waterfowl & Hunting Stamp

In 1999, the South Carolina Migratory Waterfowl Stamp entitled "Goldeneye" featured the Charleston Light. The artist, Denise D. Nelson, lives in North Carolina. The Duck Stamp Program raised $150,000 for conservation causes. All of the other South Carolina lighthouses have been included in the series, and the stamps have become collector's items. Pictured below is the duck stamp featuring the Hilton Head tower. (Both courtesy of S.C. Department of Natural Resources.)

Ruddy Ducks at Hilton Head Lighthouse **$5.50**

Expires
June 30, 1999

1998-99 SOUTH CAROLINA MIGRATORY
Waterfowl & Hunting Stamp

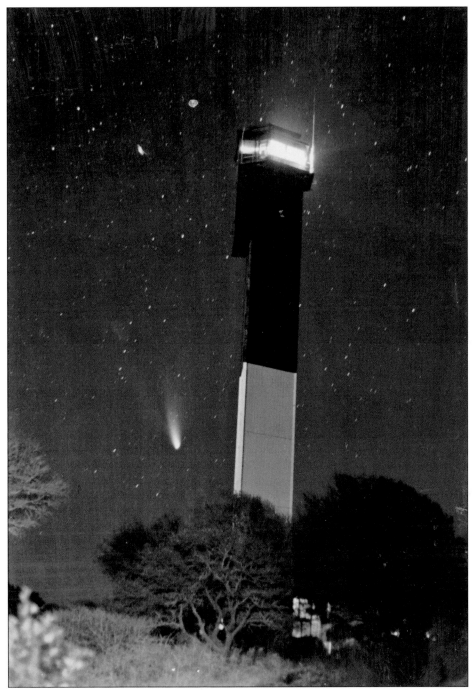

This photograph of the Charleston Light with the Comet Hale-Bopp in the background was taken by Francis White in 1997. This amazing comet was visible to the unassisted eye for more than 18 months. With its extensive media coverage, it was probably the most-observed comet in history. Shown here with the most up-to-date lighthouse on the East Coast, both the celestial phenomenon and the man-made navigational aid light up the sky above Sullivan's Island. (Courtesy of Kim McDermott; Photograph taken by Francis White.)

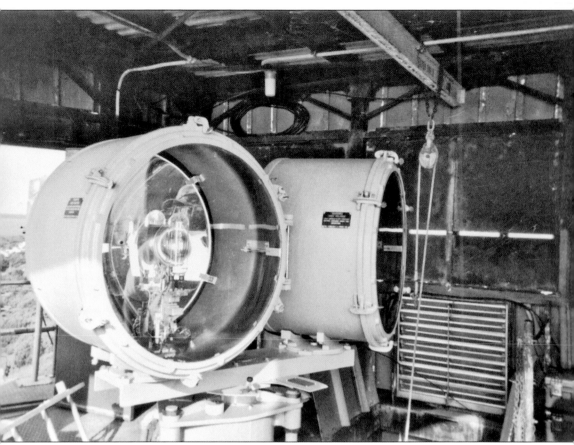

Gone are the days when a keeper had to drag whale oil up numerous flights of stairs. The beacons at the Charleston Light are fully automated, working both night and day. (Courtesy of Wayne Clary.)

The view from the top of the light is spectacular, with the homes of Sullivan's Island, the distant Isle of Palms, and the expansive Atlantic Ocean stretching out for miles. One feels like a seagull soaring over the wide expanse. (Courtesy of Wayne Clary.)

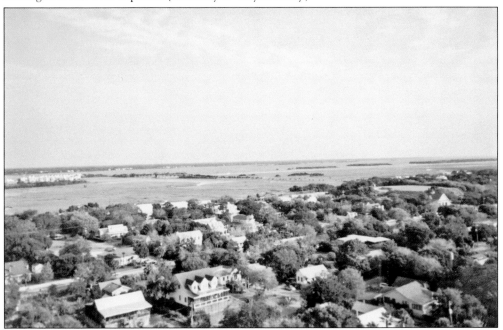

As viewed from the top of the lighthouse, Sullivan's Island has made a tremendous comeback since it was devastated by Hurricane Hugo in September 1989. Many houses were destroyed, and furniture and debris were scattered over the island. One elementary school was closed for a year. (Courtesy of Wayne Clary.)

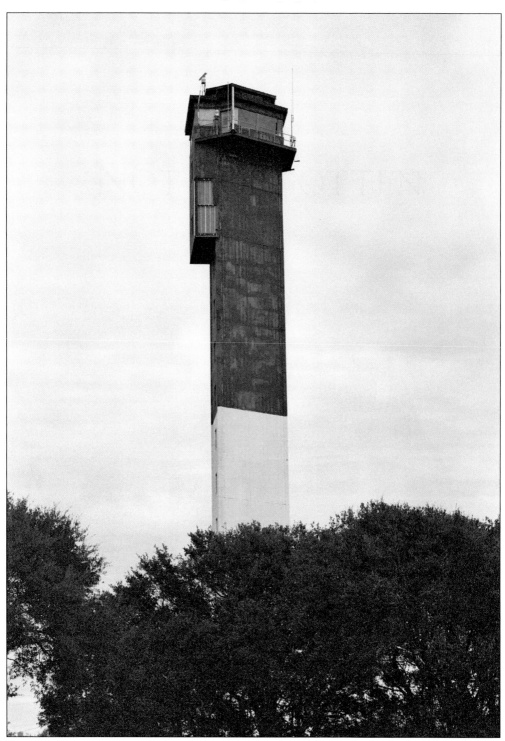

Because Charleston is such an important port on the East Coast, the lighthouse tower is essential in guiding cargo ships, pleasure craft, and even cruise ships safely in and out of Charleston Harbor.

Nine

NOT FORGOTTEN

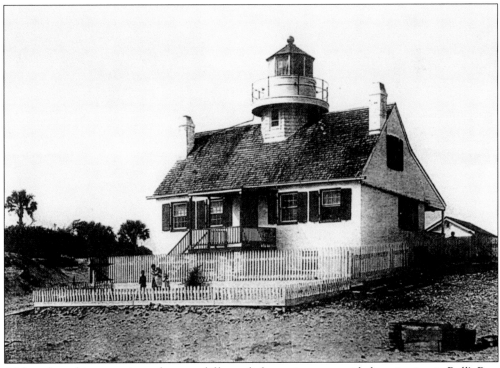

Although nothing remains today, two different light stations once aided navigation in Bull's Bay. Dangerous shoals off Bull Island caused many shipwrecks, giving the area the nickname "Bone Yard Beach." Activated in 1852, the Bull's Bay light station was located on the north end of Bull Island. The tower was part of the keeper's station in 1885. Equipped with a fourth-order Fresnel lens, the 1852 structure washed away in 1893. The keeper, Halvor Svendsen Sr., was the son of a Norwegian sea captain and went to sea with his father at the age of 8. By the age of 13, Halvor had mastered sea navigation and boasted that he would sail the seven seas. After being educated in England, Svendsen became captain of his own four-masted schooner at the age of 26. Bringing passengers and European goods to Charleston, he met and fell in love with Louisa Iusti. (Courtesy of Village Museum.)

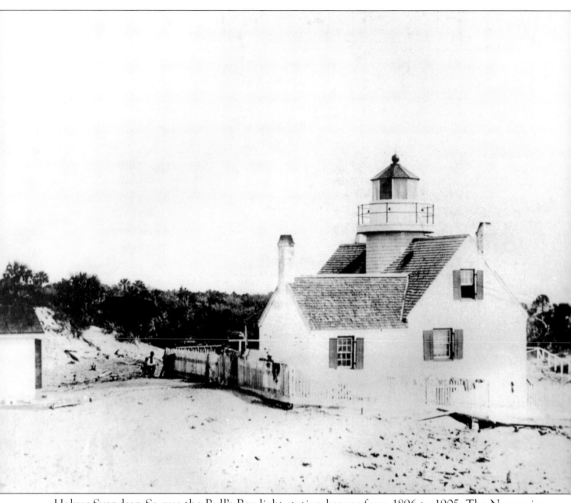

Halvor Svendsen Sr. was the Bull's Bay light station keeper from 1896 to 1905. The Norwegian sea captain fell in love with a Charlestonian, Louisa Iutsi, when she was only 16. He asked her father for permission to marry his daughter. Johann August Wilhelm Iutsi checked first to make sure Captain Halvor did not have a wife in every port and then granted his permission. After their wedding, the couple sailed to Paris, France, for their honeymoon. He took her to Copenhagen, Denmark, where she learned Norwegian. (Courtesy of U.S. Coast Guard.)

The Svendsens' first son, Carl, was born on ship in Wales. Their second son, Halvor, was named after his father. Captain Svendsen later returned to Charleston and joined the light-keeping service. He was stationed at Hunting Island and later Bull's Bay. Both sons also went into the service. Carl was an assistant at Morris Island, and Halvor Jr. worked at Cape Romain. When Halvor Sr. died at the age of 56, the light-keeping service told Carl and Halvor Jr. that whichever son wanted to care for his mother and siblings would be given the keeper position vacated by their father. Pictured above, Halvor Jr. became the keeper. (Courtesy of the Svendsen family.)

A favorite activity of the children was the perpetual search for Captain Kidd's treasure. Everyone on the East Coast knew the legends that Kidd, who was executed in England for piracy, had buried treasure on various barrier islands, possibly even Bull Island. Consequently, the imaginative Svendsen children who spent much of their time reading, liked to look for treasure. The supply boat that came monthly always brought them a new "library," a glassed, portable bookshelf with volumes of fiction and nonfiction. (Rendering by Howard Pyle.)

After he was executed, Kidd's body was tarred and hung as a warning to those tempted to try piracy.

The Bull's Bay Island Light was deactivated in 1913. Storms have destroyed the various buildings that were once there, but the island is part of a wildlife refuge and can be visited by ferry. Red wolves were once protected there but were eventually moved. Modern visitors can collect shells, enjoy bird-watching, visit Bone Yard Beach, and see the Atlantic bottle-nosed dolphins that are often viewed from the ferry. Other lighthouses that have disappeared from the South Carolina coast due to erosion, storms, and neglect are the Combahee Bank Light, which stood from 1868 to 1876 at St. Helena Sound near Beaufort, and the Parris Island Range Lights, which were in operation between 1878 and 1912. (Courtesy of Kim McDermott.)

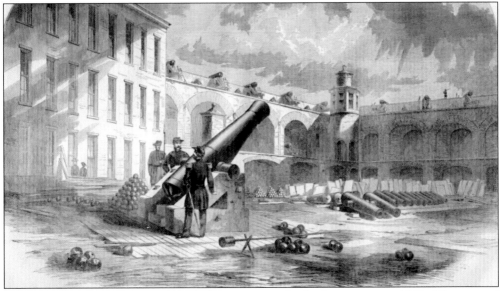

Pictured above is the Fort Sumter lighthouse over the lookout tower in 1863. (Courtesy of U.S. Coast Guard.)

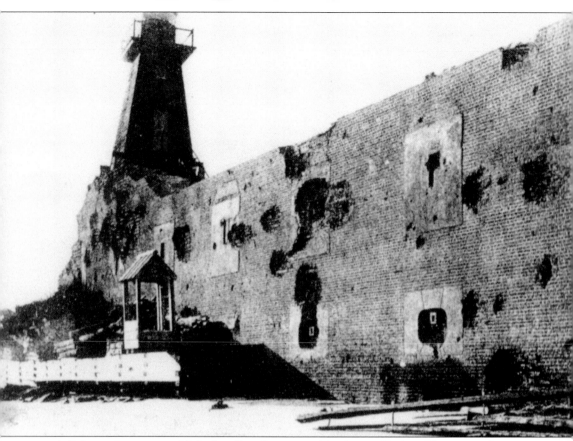

A light station was established at Fort Sumter in Charleston Harbor. The original tower was 51 feet above the high-water line and had a fifth-order Fresnel lens. It was destroyed during the Civil War and rebuilt in 1866. This picture was taken about 1870 and shows the rebuilt light. (Courtesy of U.S. Coast Guard.)

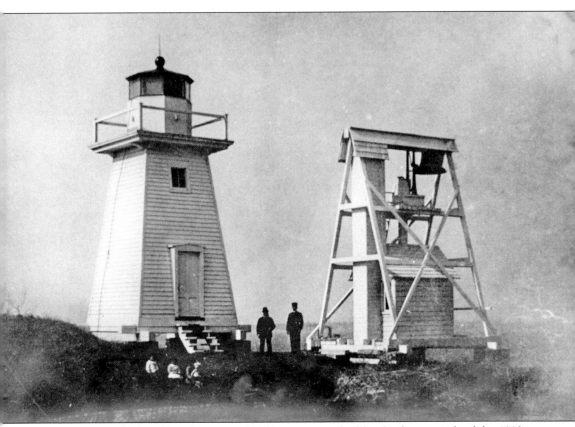

A new tower was built at Fort Sumter in 1866 but was wrecked by the fierce winds of the 1893 hurricane. A steel skeleton tower took its place, using the light in St. Philip's Church steeple as a real light to guide ships through the main channel and between the stone jetties. (Courtesy of U.S. Coast Guard.)

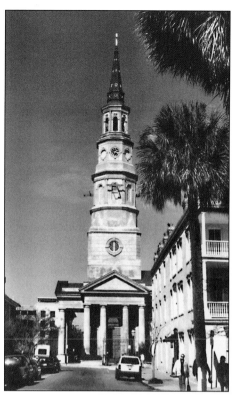

The rear range light for Fort Sumter was St. Philip's Episcopal Church, located at 142 Church Street. Its present sanctuary was built in 1838 with a steeple 140 feet high, rising above the city's majestic skyline. In 1893, a fixed white light mounted in the bell tower served as a rear range light. The Lighthouse Board paid the church $300 a year for its service as a beacon. St. Philip's is reported to be one of only two churches in the United States to have served as a lighthouse. Deactivated in 1915, the church light was extinguished. The Fort Sumter light remained in service until 1950, and a radio beacon was placed at the site. (Courtesy of Michael Willis.)

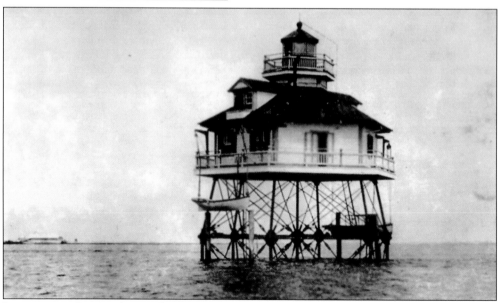

In years past, Fort Ripley was located between Castle Pinckney and Fort Johnson. During the Civil War, not a single shot was fired from this small fortification. Erosion washed most of it away after the war, leaving a dangerous, unmarked reef. The Ripley Light was built above it to prevent shipwrecks. The circular lamp cabin sat atop the second floor and had a 150-candlepower lens. The fixed red light gave warning to mariners, and during fog, a bell sounded every 10 seconds. (Courtesy of U.S. Coast Guard.)

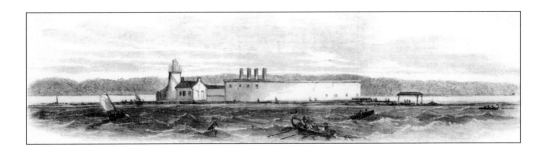

On small Shutes Folly Island in Charleston Harbor once stood Castle Pinckney. It was a two-tiered, semicircular masonry fort built in 1809. It was destroyed by the hurricane of 1804; however, it was used as a prison camp during the Civil War. In 1854, Congress appropriated funds for a small light to mark the channel into the Cooper River. In 1855, a yellow tower was built, containing a fifth-order Fresnel lens. (Above courtesy of South Carolina Room, Addlestone Library, College of Charleston; below courtesy of U.S. Coast Guard.)

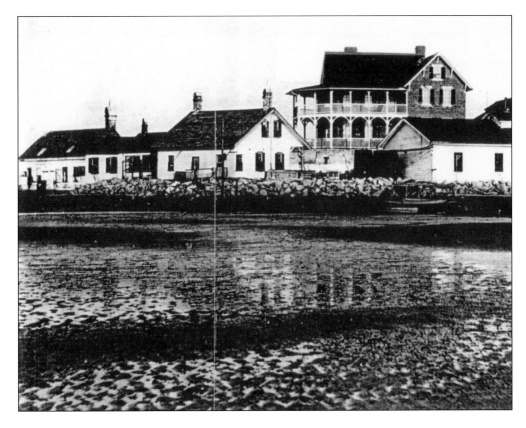

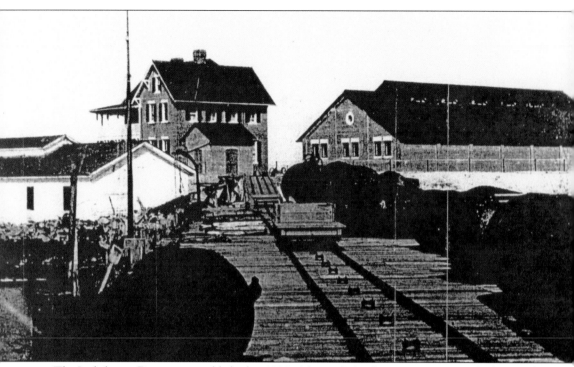

The Lighthouse Depot was established in 1880. A keeper's dwelling was constructed, along with a storehouse, in 1884. In 1890, a third lighthouse was built on the small island, and Castle Pinckney became a lighthouse station. In 1915, the Lighthouse Service moved this navigational aid to the Tradd Street base. The Lighthouse Service became part of the U.S. Coast Guard in July 1939. (Courtesy of U.S. Coast Guard.)

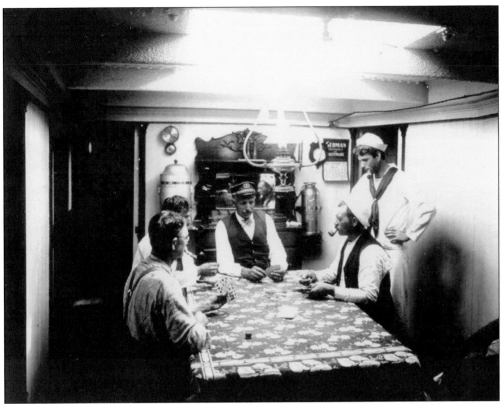

Lightships were often used offshore where lighthouses could not be built. Many of those used on the East Coast were built in Charleston. They were often in danger from other vessels, and several were struck and sunk by the very ships they were trying to guide. Crewmen had eight months of duty on board and four months on land. When not mopping deck, the off-duty crew might play cards or checkers. (Above courtesy of U.S. Coast Guard.)

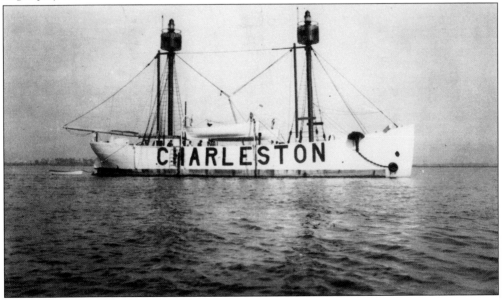

The lighthouse depot was housed in the Old Exchange Building at the end of Broad Street until 1913, when it was moved to Castle Pinckney and then later to Tradd Street. (Courtesy of U.S. Coast Guard.)

Today homeland security is an utmost concern, and the brave U.S. Coast Guard men and women who protect the country's shores are modern heroes. (Both ourtesy of U.S. Coast Guard.)

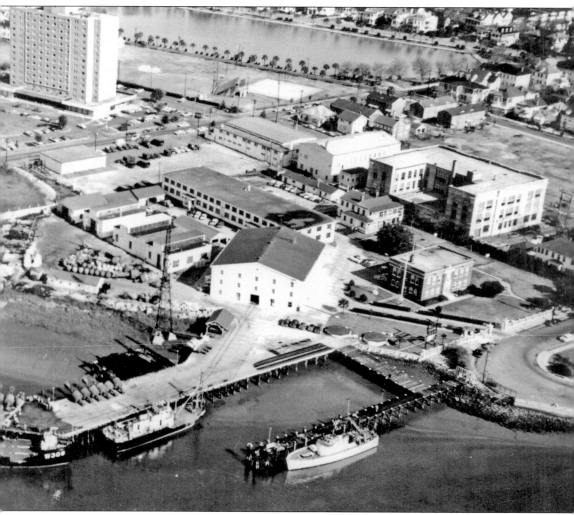

A U.S. Coast Guard station on Tradd Street carries on the great tradition of monitoring the state's shores. Two miniature lighthouse lights are on either side of the gate, symbols of an illustrious maritime history. (Courtesy of U.S. Coast Guard.)

ABOUT THE AUTHORS

Margie Willis Clary is a native of South Carolina. She has a degree in elementary education from Furman University and a master's degree in education from the Citadel. She taught elementary school for 33 years. Since her retirement from the Charleston County Schools, she has worked as an adjunct professor at Charleston Southern University and at the Citadel. In 1995, she published her first children's book, *A Sweet, Sweet Basket*, which received an honor by the *Smithsonian Institute Magazine* as a Notable Book for Children in November 1995. Since that time, Clary has written four other children's books and one adult book. Her interest in South Carolina history led to her research of the Palmetto State's lighthouses. In 1998, she penned the children's book *Searching the Lights*, giving youth the opportunity to learn about South Carolina's lighthouses. In 2005, she published her first adult book, *The Beacons of South Carolina*, a history of the state's lighthouses. Clary is also a professional storyteller and a member of the Backporch Storytellers of Charleston and the Society of Children's Book Writers and Illustrators (SCBWI). She and her husband live on James Island.

Kim McDermott holds a bachelor's degree from the College of Charleston and a master's degree in education from the Citadel. She has worked as a National Board–certified, high school English teacher and a career counselor for the Charleston County School District for 27 years. She has freelanced for many regional and national magazines, and has published two children's books and a book for guidance counselors. In 1989, she won the Blue Ridge Writer's Conference award for excellence in writing. She enjoys painting and is a member of the Charleston Artist Guild and the Folly Beach Arts and Crafts Guild. She lives with her husband and two sons west of the Ashley River.

DISCOVER THOUSANDS OF LOCAL HISTORY BOOKS FEATURING MILLIONS OF VINTAGE IMAGES

Arcadia Publishing, the leading local history publisher in the United States, is committed to making history accessible and meaningful through publishing books that celebrate and preserve the heritage of America's people and places.

Find more books like this at
www.arcadiapublishing.com

Search for your hometown history, your old stomping grounds, and even your favorite sports team.

Consistent with our mission to preserve history on a local level, this book was printed in South Carolina on American-made paper and manufactured entirely in the United States. Products carrying the accredited Forest Stewardship Council (FSC) label are printed on 100 percent FSC-certified paper.

MADE IN THE USA